RHODE ISLAND BEER

OCEAN STATE HISTORY ON TAP

ASHLEIGH BENNETT
& KRISTIE MARTIN

Foreword by Sean Larkin, president of the Rhode Island Brewers Guild

AMERICAN PALATE

Published by American Palate
A Division of The History Press
Charleston, SC 29403
www.historypress.net

Back top cover image courtesy of Greg and Ed Theberge; front top image courtesy of
William Lester, www.flickr.photos/williamlester.

First published 2015

Manufactured in the United States

ISBN 978.1.62619.738.1

Library of Congress Control Number: 2014959948

Notice: The information in this book is true and complete to the best of our knowledge. It is
offered without guarantee on the part of the authors or The History Press. The authors and
The History Press disclaim all liability in connection with the use of this book.

CONTENTS

CONTENTS

FOREWORD

My entrance into the brewing world was very much unplanned and serendipitous. I was working as a line cook and dishwasher at Trinity Brewhouse when I was asked to join its brewing team. At the time, Trinity was Rhode Island's second brewpub, as Union Station brewpub had opened up one year earlier. The only other microbrewery operating at the time in the state was Emerald Isle, which was way ahead of its time, as it only offered cask-conditioned ales. I had left Trinity months earlier to take a chef's position at the Cactus Grill, only to have the place close down a few months later. Lucky for me, I had left Trinity on good terms, and it took me back with open arms.

Our brewers at the time were brothers, and at some point, they had had a difference of opinion that left the brewery team in need of an apprentice. Kurt Musselman, head brewer at the time, poked his head out of the brewery one day, looked at me and said, "You! You said you wanted to learn how to brew, right? You start tomorrow!" I was like, "...ok?!"

From that point, my life changed forever. I was one of six people brewing beer professionally in the state, and it was awesome—a dream job for a twenty-one-year-old. I had been inducted into a family unlike any other on the planet: the Brotherhood/Sisterhood of Brewers. Not just that but New England brewers as well—hardened men and women brewing in the wilds of the Northeast. Our neighbors to the west (West Coast brewers) laughed at us, and our mentors from the east (Europe) shook their heads and scoffed at what we did with beer.

As New Englanders, we had beer in our blood since the time of the Pilgrims. When I started out in 1994, Sam Adams and Harpoon were the biggest, with maybe Long Trail coming up third. Otter Creek and Catamount were barely blips on the radar in Rhode Island. In Boston, there was a strong brewpub contingent that was pushing new styles and setting trends. I became aware of names like Tod Mott, Will Meyers, Dan Paquette, Jeff Bekard and Tim Morse from places like Cambridge Brewing, Northeastern Brewing, John Harvard's and Boston Beer Works, as well as brands like Harpoon and Tremont. These dudes were making incredible beers, and they were hanging out with one another, sharing tips and pushing style guidelines.

All of us were different in our own ways, and in the beginning, I fumbled to find my place. I was an awkward twenty-one-year-old assistant brewer who took over a $3-million-per-year brewpub within his first year of brewing. People wondered how I even got the job. The people of the homebrew community were the toughest to crack, as they thought I didn't deserve the job because of my lack of experience. Older brewers in-state and out of state, my "would-be mentors," were also generally skeptical of my skills or longevity. Generally, most people outside Rhode Island thought that Rhode Island was insignificant and that our brewing scene would probably just die off.

All of those assumptions were most likely warranted at the time. But then I started winning awards, and that validation was all I needed to push harder and become even more of a monster. At twenty-five years old, I had the city of Providence behind me and felt unstoppable. Still, there were haters, critics and people who were just downright nasty. I learned that this beverage that we called beer made friends as well as enemies. That was something I was less prepared for at that age. Lucky for me, I had some key people in my life who kept me centered and grounded, but I still somehow felt lonely. I looked at states like Massachusetts, Vermont, California and Colorado, and I was jealous. All of those states had more breweries than you could shake a stick at.

I came from tiny little Rhode Island. There were three of us when I started. Most brewers in the Midwest thought we were part of New York. Still, I pushed on with the vision that I would make a splash that people would remember. I would make them remember.

More breweries started coming online with the arrival of Coddington Brewing, Newport Storm and Mohegan Café and Brewery. The family started growing, and it was awesome. People began to really follow the brands, and brewery loyalty developed. Although at times people might have thought we all hated one another, the truth was that we were excited for the

growth. Even if people were talking about the brands and comparing them to one another, at least they were talking and drinking.

In 2006, I started working for and helping to rebuild one of the biggest New England heritage brands, Narragansett Brewing. I helped it build out a solid craft beer portfolio that now covers a fourteen-state territory. It was amazing to see recipes that I built out on a brewpub level brewed and packaged at a one-thousand-barrel level. I was helping to rebuild a brand that originated in the late 1800s, and now I was part of that legacy.

"Hi, Neighbor! Have a 'Gansett!" was the slogan. 'Gansett's rebirth and legacy helped pave roads for new Rhode Island brands and breweries to emerge. In the past four years, we have had nine new brewers' licenses issued. We now have an active brewers' guild with a growing membership, and if that wasn't enough, I started a revival. The little "Rhody" brewing community is growing. There has never been a better time than now to enjoy homegrown products!

Sean Larkin
Cofounder of Revival Brewing Company
Brewmaster and Consultant at Narragansett Beer
President of the Rhode Island Brewers Guild

Acknowledgements

We would like to thank the following people.

Our commissioning editor, Tabitha Dulla, and the rest of The History Press for giving us this chance.

Greg Theberge, who allowed us a glance into his and his father's unmatched Rhode Island breweriana collection and provided many of the images for this book.

Illustrator and friend Sara M. Lyons for our whimsical Rhode Island map—from LJ to PRB to being published!

To Sean Larkin, for taking the time out of his busy schedule to write our foreword.

To all of the fans and followers of "Two Girls, One Beer"!

To everyone we interviewed, thank you for sharing your story: Mark Hellendrung, Bill Nangle, Ray McConnell, Marshall Righter, Billy Christy, Brent Ryan, Robert DeRosa, Tommy Tainsh, Alan and Jen Brinton, Nick Garrison, Dorian Rave, Dave Witham, Nichole Pelletier, Jason Lourenco, Andy Tran, Josh Dunlap, Wes Staschke, Matt Richardson, Nate Broomfield, Meredith Crane, Charlie Baron, Chris Meringolo, Brian Oakley and everyone else involved in this amazing local beer scene.

Thank you to Larry Brown at Yankee Brew News, for helping spread the word; Matt Medeiros; Anthony Belz; the Haffenreffer Museum of Anthropology; Brown University; everyone who donated to the Kickstarter, especially Walter Cekale and Jeff Lesperance; and Matt Gray at Gray Matter Marketing.

From Kristie: Thanks, Al, for giving us the space to brew our first homebrew together; everyone at the What Cheer and WHYM; and Mom, Dad and Leigh for your constant love, support and encouragement.

From Ashleigh: Thanks to Mom, Dad, Chelsey and my husband, for letting me always trying sips of your beer when we go out and for always encouraging me to write. Thanks to all of the authors behind the books that inspired me to write. Mischief managed, and m-o-o-n spells *moon*—here's my book!

To Alex and CT: Thanks for putting up with all the beer we never let you drink because we're saving it, and thanks to "the Cats"—Meena, Spooky, Scaredy (my little space heater) and, of course, Binx.

INTRODUCTION

Cut to years past. Two girls on a kitchen floor, wrapping the lid on a five-gallon plastic bucket with duct tape, trying not to spill our first homebrewed batch of red ale. There were frantic calls to parents with homebrewing experience asking if it's okay that we don't have a tight seal on our mismatched bucket and lid set. That was also the year of pouring a boiling batch of wort into a plastic jug and watching the horrifying chemistry that ensued, as well as the time we tried to condition a lager during the hottest week of summer. Our hearts were in the right places, but we essentially lacked any and all technical brewing skills. Like most college students, quantity came well before quality. Refining our palate meant choosing the tropical fruit-flavored St. Ides forty-ounce or buying a Unibroue Trois Pistoles solely because of the epic winged horse on the label.

We think the "craft" part came along after graduating and moving back to our home of Cape Cod, Massachusetts. Some friends lounge at the beach or hit the bars. Sure, we do that, too, but the basis of our friendship has always been food. Our Friday nights would consist of cooking epic meals, learning how to pickle and can the vegetables we'd grown or going out on hunts for the best local oysters or pungent cheeses. Our love of cooking developed into a sort of DIY kitchen ethos, and that led to homebrewing and to the discovery that beer, like anything else, can be an art and passion rather just the means to a hangover.

We started our beer website, like lots of beginning bloggers, to discover new beers, learn what we liked and get connected with other likeminded

people in the area, especially other women because, let's face it, sometimes there's nothing else to do during a Cape Cod winter except drink. Since then, we've experienced beer communities all over New England. Kristie cut her bartending teeth out in Portsmouth, New Hampshire, while Ashleigh worked for various publications, covering the expanding eastern Massachusetts beer scene.

It's interesting to muse on how beer has been perceived over the years. Today, it is a thriving business as well as a subculture of connoisseurs, professional beer bloggers and studio apartment homebrewers. What used to be a grueling household chore tagged onto a Puritan woman's workday is now a #craftbeer-filtered newsfeed on Instagram. As prudent and puritanical as the Pilgrims were upon their coming to America, they loved their beer. To them, beer was safer than water and viewed as "liquid bread"—an important source of nourishment. The *Mayflower* had originally been destined for Virginia, but the navigators chose the sandy tip of Cape Cod after realizing that they were horribly off course and about to run out of beer. Their leader, William Bradford, wrote in his journal, *History of Plimoth Plantation*, "We had yet some beer, butter, flesh, and other victuals left, which would quickly be all gone, and then we should have nothing to comfort us." The history of our favorite beverage runs deep throughout New England and especially Rhode Island, which boasts some of the country's oldest and most successful breweries.

Brewery growth and craft distribution has been slow to reach Rhode Island, but as we write this now, there's probably another brewery in its planning stages. Rhode Islanders have a certain type of state pride that goes unmatched. Unfortunately, after years of being a craft beer wasteland, people stopped viewing Rhode Island as a beer-producing state.

Since then, Newport Storm helped pioneer the limited-release beer as well as canned beer in New England. Providence's Trinity Brewhouse sparked a wave of brewpubs, and Narragansett Brewery, once the top beer in New England throughout the late 1800s, is now the fastest-growing brewery in the Northeast. Now when people think of Rhode Island beer, it's more than in just a historical context. People have begun to recognize the quality beer being produced in the state from breweries like Foolproof and Grey Sail. Even newcomers like Proclamation Ale have proved to others that Rhode Island is more than a passageway to New York but rather a destination in itself. We spent a year traveling up and down the state to meet all of these brewers and learn their stories—usually over a beer, of course. What we saw were people determined to make their passion a reality and

to bring good beer to their home state. These are brewers who want people to remember the experience of drinking their beer—to remember that it's a social beverage and not just a BeerAdvocate rating.

The brewery landscape is constantly evolving in our small state, and there are many new breweries at various stages of the opening process. Most of the interviews and research for this book were conducted in the summer and fall of 2014, so at the time of publication, it may not be completely up to date. For the most current information, be sure to consult the brewery websites before planning your visit. In the meantime, join us in cracking your favorite Rhody beer and learn more about what is and always has been brewing in the Ocean State.

Chapter 1

The Ocean State Originals

Rhode Island's First Breweries

Beer in Early Rhode Island

Many of our country's "firsts" can be traced back to Rhode Island. The Portsmouth Compact, signed on March 7, 1638, was the first document that severed political and religious ties with England. Two months before the Declaration of Independence, Rhode Island became the first British colony to formally declare independence on May 4, 1776.

As a state of "firsts," it is no surprise that some of its original boasts surround beer. Two years after Roger Williams was booted from Boston and founded Providence, Sergeant William Baulston was given license to run a public house, providing Providence with groceries, wine and homebrewed beer, making the Baulston Brewery one of the oldest known breweries in America. Newport's White Horse Tavern, recognized as the oldest bar in America, opened its doors in 1673, becoming a haven for anyone searching for a drink, from colonists to British soldiers, pirates to Founding Fathers. It also served as a courthouse, Rhode Island General Assembly meeting place and a place for gossip and catching up with friends, as well as city hall.

William Mayes Sr. acquired the tavern license for the building in 1687, and his son, William Mayes Jr., a well-known pirate, operated the tavern throughout the eighteenth century. Beer was cheaper at taverns back then than now. In 1634, a quart was one penny, and a sixpence was the regulated

price for a meal. Akin to the tavern were dockside taverns, America's first dive bars, for sailors and working-class dockhands. They were called slop shops, tippling houses and grogshops. The owners of these bars were usually retired sailors.

Why was beer so important to the settlers? Quite simply, beer was safer than water. Water spoiled quickly and did not last long enough on boat voyages, whereas beer was viewed as a safe and spoil-free beverage. Over in their motherland of England, drinking water was a risky practice. Streets overflowed with sewage and pollution, and germs had not yet been discovered. When the water to make beer was boiled, it became sanitary. Before the advent of microbiology, people did not realize that the act of boiling water for beer is what made it safe and that boiling drinking water would have the same sanitizing effects; hence, they stuck with beer, the mysteriously safe beverage. Water, on the other hand, could be deadly.

Homebrewing was also common in early America since transport was limited. Kitchens were made to accommodate brew space, and housewives took over brew duty. Everything had to be done with locally available resources, which meant that substitutions were common. Luckily, purity laws did not affect homebrewers and brewers who did not own taverns, and this led to ingenuity in substitutions and the rise of drinks like sassafras and birch beer. Corn was often substituted for malts in the early colonies.

One Rhode Island brewer, Major Thomas Fenner, was known for his homebrew and substitutions. One of his recipes called for "[o]ne ounce of Sentry Suckery or Sunlindine. One handful Red Sage or large ¼ pound shells of iron Brused fine, take away 10 quarts of water, steep it away to seven and a quart Molasses Wheat Brand Baked Hard. One quart of Malt one handful Sweeat Balm. Take It as Soone as it is worked."

New England was never a region widely regarded as barley-growing territory, but some farmers in Rhode Island were able to successfully grow the grain. In 1796, barley was actually listed as the state's leading agricultural product. Records show two maltsters in Portsmouth, Matthew Greenell and Daniel Greenhill, operating in the late 1600s.

Rhode Island—or, going by its formal name, the State of Rhode Island and Providence Plantations—was apparently flowing so freely with beer that by 1655, its four towns (Providence, Portsmouth, Newport and Warwick) had declared that each town could only be allowed two innkeepers. All of this occurred in a state with no political or financial support from England.

By the early eighteenth century, Newport had established itself as the rum capital of the world. Twenty-two distilleries were operating in the city,

using blackstrap molasses and pot stills to create the flavorful spirit sought the world over. During the second half of the century, though, things turned downward. The Sugar Act of 1764 increased the cost of sugar and molasses from the Caribbean. Because Newport was occupied by the British during the Revolution, many rum merchants had to abandon their businesses, and by 1817, only two distilleries remained in the once thriving seaport city.

Newport had a brewhouse as well, owned by George Rome, who represented English businessmen and took the title to the house to cover a debt. His brewery was on Spring Street, south of the First Baptist Church. There it stayed until the American Revolution, when Rome returned to England. One Newport brewer, Giles Hosier, rented space in the basement of the statehouse to lager his beer.

Rhode Island is truly unique from a geographical standpoint. Although it stretches only forty-eight miles from top to bottom, the state is a travel agent's dream because it can literally be advertised as something for everyone. You have the thriving harbor-side destination that is Newport County, the sprawling beaches and farmland of South County, the historic laidback charm of the East Bay, the rivers and woodlands of Blackstone Valley and, of course, the cultural epicenter that is Providence. It becomes easily understood why the area was such a hotbed for breweries in the days before Prohibition. Rhode Island was at the forefront of the Industrial Revolution and the establishment of power-driven textile mills. This was an area of fishermen, farmers and millworkers—couple that with a fierce, independent streak and a growing number of entrepreneurs looking to spread out from Boston and Europe, and someone is bound to start brewing beer.

At the Corner of Fountain and Jackson Streets

This is the story of the building located on the corner of Fountain and Jackson Streets in Providence. We'll admit that the history of this building reads a bit like the Book of Genesis—Shem begat Arphaxad, and Arphaxad begat John Bligh, who begat the Narragansett Brewery, which begat the James Hanley Brewery and so on. But this series of breweries is a remarkable piece of history and part of the foundation of modern New England brewing as we know it.

On June 24, 1824, two brothers from Sharon, Massachusetts, bought a cheap piece of land at the corner of Fountain and Jackson Streets in Providence,

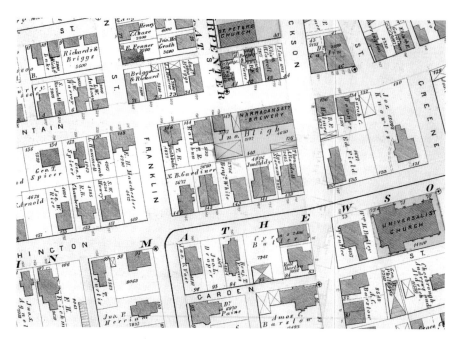

An 1875 ward map showing the location of John Bligh's Narragansett Brewery. *David Rumsey Map Collection.*

Rhode Island. They built a home for themselves and a small brewery. With that, Oliver and Otis Holmes began a legacy of brewing at Fountain and Jackson that would continue for 133 years. The Holmeses kept it in the family for the next 40 years. Sons George Otis and Charles Butler Holmes, later joined by Daniel Holmes, worked in the brewery, producing eight barrels a day for their first year with the help of brewer Alexander M'Cullock. Oliver and Daniel died young, and Otis Holmes, after a short stint of political imprisonment for his involvement in the 1842 Dorr Rebellion, subsequently retired. The year 1867 was the last in which a member of the Holmes family brewed beer at the corner of Jackson and Fountain. John Bligh was recognized as brewer at the location in 1868, calling his new venture the "Narragansett Brewery"—no relation to the Narragansett Brewery we've all come to know. Blight brewed a porter, a pale and an amber ale and, according to the city directory, continued to do so until 1874.

Cut to John P. Cooney, a wine and liquor distributor who ran his business on Canal Street. An Irish immigrant, Cooney moved to the United States and settled in Providence when he was nineteen years old. The Civil War raged on, and Cooney began producing his own line of bitters, syrups and cordials,

eventually branching out into the beer business in 1876 with his good friend James Hanley, a wine and spirits importer and fellow Irish immigrant.

So, Bligh was running the brewery over at Fountain and Jackson, Cooney and Hanley were selling wines and all the while, a small brewery called Merchants Brewing Company was operating over at 87 East Avenue in Pawtucket. The two friends purchased the brewery in 1876, and all was well and good until 1879, when John Cooney became sick and passed away at the age of forty-one. The brewery became known as the James Hanley & Co. brewery, also known as the Silver Spring Brewery.

In 1879, Hanley got the itch to expand and leased from Ellen Bligh the brewery at the corner of Jackson and Fountain. Hanley incorporated his brewery with William Carney and Charles A. Mathewson, and in 1883, it became the Rhode Island Brewing Company. They brewed an India pale ale, a porter and a Canada malt ale called "very rich in nutriment, a delicious family beverage, and especially adapted for invalids." The brewery became officially recognized as the James Hanley Brewing Company in 1895, producing Peerless Ale, India pale, Pale Export and cream ales, as well as a popular porter. It developed its first advertising icon, a doughy-faced aristocrat known as "the Connoisseur," which was followed up in 1913 with the slightly more likeable British bulldog, the "Watchdog of Quality."

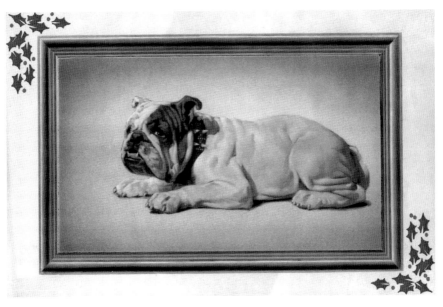

Frederic Stanley painted the Hanley's Watchdog in 1913. In 1941, the image would be succeeded by "That's My Pop," featuring a bulldog puppy. *Greg and Ed Theberge Collection.*

Hanley's Peerless Ale

The James Hanley Brewing Co.

The nineteenth-century version of a "'Gansett Girl"—pinkies up with "the Connoisseur"! *Greg and Ed Theberge Collection.*

Hanley's was known for its "World Famous" six- and nine-strong Belgian horse wagon teams. *Greg and Ed Theberge Collection.*

Hula and Hanley's at the Rocky Point Bar, located at Warwick's Rocky Point Amusement Park (1847–1993). *Greg and Ed Theberge Collection.*

Hanley's was a recognizable brewing force, with its team of Belgian draft horses seen at parades and fairs across New England. This was decades before Budweiser monopolized the horse market. Hanley's sons took over the company after his death in August 1912, and the company continued to thrive. It bottled its own beer and marked each beer style with uniquely colored labels to make each offering recognizable. It even participated in the great "bottle versus can" debate going on to this day. In a 1937 *Telegraph*

Hanley's powered through the 1940s and early '50s, brewing with spring water from its own Silver Springs located on-site. *Greg and Ed Theberge Collection.*

article, Hanley's touted, "We could have done so earlier [offered cans]— with extra profit to ourselves—but we waited until we knew we had the very best canning equipment—and the very best can—crown sealed."

The company sailed through Prohibition with the production of a near beer known as "Limited." Hanley's and Narragansett both emerged from the dry days, each running strong with its own advertising campaigns and both sponsoring sports teams and political campaigns and producing radio jingles.

After 1850, German-owned breweries began to dominate the beer market throughout New England, especially around Boston. They had a large market for their beer, and many Americans were attracted to these lighter, sparkling German-brewed lagers in comparison to darker ales. This subtle change in taste may have helped influence the events of May 2, 1957, when Carl Haffenreffer of Narragansett Brewing Company bought the Hanley brand. On March 14, 1960, all equipment was removed from the brewery for its eventual demolition, thus ending the 133-year brewing history at the corner of Fountain and Jackson.

WHAT CHEER BREWERY/CONSUMER'S BREWING CO.

For an authentic beer vacation, pack a picnic lunch and take a venture down memory lane—or, more accurately, down Cranston's Molter Street—to gaze at the crumbling foundation of what once was a thriving Rhode Island brewery, the What Cheer Brewery, later to become Consumer's Brewing. Started in 1866 as the Kelly & Baker Brewery, the company would undergo numerous name and ownership changes, most predominantly of which was Nicholas Molter's What Cheer Brewery.

If you're not from Rhode Island, chances are you've never heard the phrase "What Cheer?" Before the brassy intensity of the "What Cheer?" Brigade or the Washington Park watering hole the What Cheer Tavern, the Providence motto came into existence when the Narragansett tribe greeted Roger Williams with,

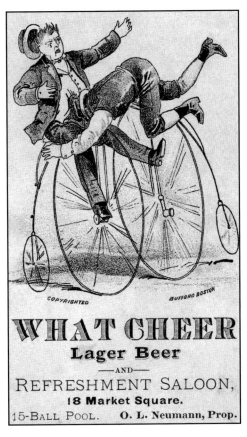

Penny-farthing under the influence. *Greg and Ed Theberge Collection.*

"What cheer, netop?"—a seventeenth-century version of, "What's up?"

Molter, born in Germany in 1818, worked as a blacksmith before immigrating to the United States in 1840. A prominent member of Rhode Island's German American community, Molter bought Andrew Woefel's Cranston brewery and began producing What Cheer lager beer, a popular beer of the time, sold throughout New England. Molter and his two sons, Henry T. and John N. Molter, operated out of the Cranston facility, as well as numerous offices in Providence, with the two taking full control after the passing of their father in 1896. In 1905, the brewery began producing its Princess Ale, advertised as "brewed especially for

What's in a name? Breweries of yesteryear often went through numerous name changes. The What Cheer Brewery became Consumer's. *Greg and Ed Theberge Collection.*

families and recommended by the medical profession." Beer as a health tonic was a popular marketing campaign of the time. Advertisements would often flaunt the nourishing qualities of malt and the invigorating properties of hops.

In 1911, Henry Molter changed the brewery's name to Consumer's Brewing Co., which was known for its Minster lager beer. The new venture was short-lived. Molter quit the brewing business in 1915, shortly before the enactment of Prohibition. Consumer's shut its doors, never to reopen.

THE HAND BREWING COMPANY

The story of Pawtucket's Hand Brewing Company would make for a great movie featuring overused tropes like a newsie shouting, "Extra, extra, read all about it!" over a spinning headline featuring spousal abuse, bootlegging and corrupt politicians.

Located at the corner of Mendon Avenue and Freemont Street in Pawtucket, the Hand Brewing Company was started by Michael Hand Sr. This wasn't Hand's first foray into the brewing business. He had previously worked with the Gulf Brewing Company out of Utica, New York, and the Scranton and Lackawanna Brewing Companies of Scranton, Pennsylvania. Hand had four children. His son Michael Hand Jr. would follow his father into the brewing business. Michael Jr. married Annie Connell in 1890, and the family moved from Scranton to Pawtucket, where they lived on Cottage Street and raised a family of seven children.

One would think that with seven kids and a booming beer business, a family would be pretty happy; not the Hands, though. Stories of abuse and verbal attacks flooded the *Pawtucket Times*, with Hand Jr. charged with multiple cases of assault, notably declaring that a "wife like his would drive the judge to drink." Our "favorite" incident is one that occurred in 1908, when Louis Ullman sued the brewery for $25,000 in damages after a brewery employee shot him in the eye. Apparently, it was Hand Brewery custom to keep three unloaded revolvers in the office desk, and it was "common practice of employees at that time to point these revolvers at persons entering the office." A higher-up gave the order for the guns to be loaded, and one day, when thirteen-year-old Ullman entered the office to make a delivery, he was shot in the face. Through all of the scandals, the Hand Brewery still thrived with the production of its celebrated Half Stock Ale, Lager and Porter. The brewery produced 100,000 barrels per year and even owned its own bottling facility.

Michael Hand Sr. died in 1911, leaving control of the brewery completely in Michael Jr.'s hands. This reign would be short-lived, as Michael Jr. succumbed to pneumonia four years later at the age of forty-nine. The brewery that proclaimed it produced "the beverage for the man

Antique bottle opener from Pawtucket's Hand Brewery. *Greg and Ed Theberge Collection.*

that works" was turned over to Michael's wife, Annie Hand, who served as president and treasurer.

In 1919, Congress approved the Volstead Act, which limited the alcohol content of any beverage to less than 0.5 percent. These low-alcohol beverages were known as tonics or near beers, and many breweries made the transition. The Hand Brewing Company was one of these breweries given permit to continue functioning, producing a low-alcohol version of a pilsner and a stout, as well as a sparkling tonic.

Of course, the Hands couldn't leave well enough alone, soon becoming the only Rhode Island brewery to produce full-alcohol-content beers under the radar during Prohibition. The brewery was raided by federal officials on numerous occasions, although according to a 1983 *Pawtucket Times* article, Annie's son Robert Hand was under the impression that they were given legal permission to continue brewing by a local politician. Of course this story needs a seedy politician; enter Mr. James Lavell, a local realtor known for twisting the system in his favor.

Lavell had previously worked for the James Hanley Brewing Co., Hand's biggest competitor. Using his political prowess, he was able to get Hand Brewing products boycotted from many Pawtucket bars, costing the Hand Brewing Co. close to $1 million in lost revenue. Lavell was also a bottler and wholesale liquor dealer. His business at 24–28 Fountain Street in Providence was a known speakeasy, claiming to have the "longest bar in Rhode Island." Although police were making booze busts across the city and the local precinct was right next door to the Fountain Street saloon, the police never bothered Lavell. He eventually parted ways with Hanley and went on to distribute for Annie Hand, who was struggling to keep the brewery afloat amid the grip of Prohibition.

If Hollywood has taught us anything, it's that you never enter into business with your previous rival; even though he promises he'll be on your side, he will turn on you. With no other options, Hand asked Lavell for a mortgage, putting the brewery up as security. No surprise that Lavell foreclosed on the mortgage; Annie was unable to pay the loan, and thus, in 1921, the Hand Brewing Co. was given to James Lavell. Yes, he continued to brew illegal beer along the way. What is now the Coffee King on Fountain Street used to be one of Lavell's realty offices. During Prohibition, clients would come in and order kegs of full-strength beer. These kegs were also shipped down the street to the speakeasy. Although he received numerous fines, by 1926 the new Hand Brewing Co. was producing sixty thousand barrels of illegal beer. Eventually, the government caught up with Lavell, and he

was arrested in 1931 for federal tax evasion and convicted for concealing $102,000 worth of bootleg beer. He was sentenced to eighteen months at the Atlanta State Federal Penitentiary, where he would serve only half his time and immediately reenter the brewing business upon his release. He renamed the brewery the Rhode Island Brewing Company, but it would only last for five years due to strong market competition.

In 1939, James Lavell was found dead in his garage, slumped behind the wheel of his car with a cigar still burning—victim of an apparent heart attack. The brewery was slated for demolition in the coming years, but if you venture down Mendon Avenue where Hunts Avenue turns into Freeman Street, you'll see that the red brick building still stands.

PROVIDENCE BREWING COMPANY

This brewery was originally known as the American Brewing Company when it opened in 1892. James Hanley took over as president in 1896,

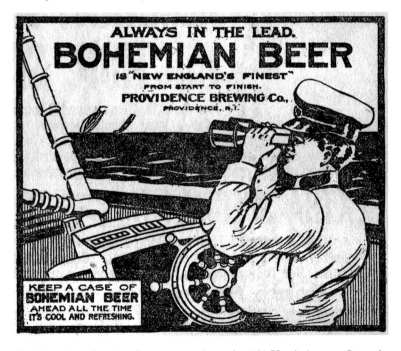

The Providence Brewing Company was located at 431 Harris Avenue. *Greg and Ed Theberge Collection.*

renaming it the Providence Brewing Company. The brewery was known for its "New England's Famous" Bohemian Beer, as well as a Canada malt and a porter, although like most other operations of the time, it was closed with the enactment of Prohibition. In the early 1900s, the brewery saw significant improvements, incorporating newly introduced refrigeration technology and modern brewing practices. By 1900, the company had one hundred workers and was producing 200,000 barrels a year. Of all the large pre-Prohibition breweries in the Providence area, the Providence Brewing Company is one of the only buildings left standing. It was even once considered to become the new Narragansett brewery, but it would have been a hefty investment to make the building structurally safe. In early 2014, a proposal was brought before the Rhode Island Historical Society to establish the building as part of the National Register of Historic Places, strengthening the significance of brewing in downtown Providence over the centuries.

Narragansett Brewing Company

There's nothing more Rhode Island than stuffies,* Del's and Coffee Milk, except for maybe cracking open a Narragansett (affectionately called 'Gansett by locals). As the longest-running brewery in the Ocean State, Narragansett is a Rhode Island staple. It's nearly impossible to find someone who doesn't have familial ties to the brewery—an uncle who worked the canning line and memories of stealing their dad's 'Gansett from the garage. Narragansett is entrenched in the collective memory of the state.

In the late 1800s, German-owned breweries were a large sector of the brewery scene. The surge in popularity, ironically, was associated with the temperance movement, during which ale, as opposed to harder alcohol, was the beverage of choice. Germans brought centuries of experience in lager brewing to America, and their light and effervescent beer quickly caught on and eclipsed the heavy, dark American ales.

German-owned breweries were gaining hold in Boston, so it makes sense that in 1890, just fifty miles south in Providence, six German American immigrants—Jacob Wirth, Constand D. Moeller, George Gerhard, Augustus F. Borchandt, Herman G. Passner and John Fehlberg—joined forces and established Narragansett Brewing Company. Their initial capital of $120,000 to $150,000 came from Fehlberg's invention of "butterine," a primitive version of what we today know as margarine.

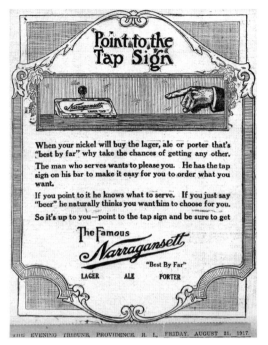

Narragansett's "Point to the Tap" campaign used brass tap markers to ensure that the beer being poured was, in fact, a 'Gansett. *Greg and Ed Theberge Collection.*

Narragansett may have claimed that it was located in Providence, but to the discerning Rhode Islander, it was actually just outside the city in Cranston. The brewery's prime location provided everything it needed at arm's length. The Arlington neighborhood where the brewery was located, at the corners of Depot Avenue and Garfield Avenue, was known for its artisanal wells and good water and was located just off the New York City rail line.

Narragansett ran strong during its first thirty years and surpassed all others to become the largest brewery in all of New England. The first Narragansett brewmaster was George Wilhelm, and he began brewing Narragansett Half Stock Ale and Narragansett Export Lager. In his first year, the brewery produced 397 barrels of beer. In an exponential increase, the brewery made 27,887 barrels in 1891. In 1900, these numbers increased again to 101,469 barrels, and by 1908, the brewery was making 196,173 barrels annually. In addition to its Half Stock Ale and Export Lager, the brewery had also started making limited, seasonal runs of porter and bock. With numbers like this, it was time for the brewery to expand.

By 1915, Narragansett had developed a self-sufficient brewing empire, becoming the largest brewery in New England, and unlike many other breweries of the time, it could do almost anything in-house. It occupied forty-two acres with more than thirty buildings, including a bottling plant. Much like the canning lines of today, most breweries of the era would hire a third party to bottle their beer, so this placed Narragansett a cut above the rest. It also had its own cooperage shop, carpenter, blacksmith and cold storage basements. It built a stable and a garage big enough to house the

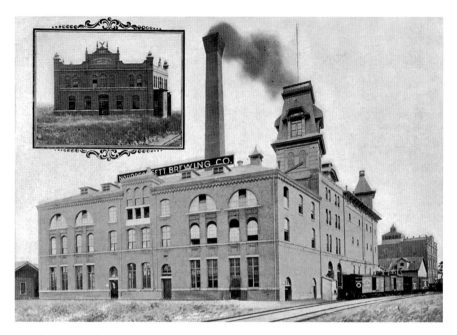

Exterior shot of the old Narragansett Brewery. *Greg and Ed Theberge Collection.*

wagons and horses it used for transport. The horses were eventually replaced by automobiles but were kept around as mascots of sorts to represent their heritage at fairs, parades and other events in Rhode Island until the 1960s.

It's strange to think of something as commonplace as ice and refrigeration being commodities, but in the early 1900s, they definitely were. Narragansett made its own artificial ice with high-quality well water, and because of this, it built an icehouse and an ice pond and had three refrigeration machines. Ice was one of the only ways to refrigerate back then, and Narragansett delivered twenty-five tons of ice to more than 1,500 customers. Between this and its beer, Narragansett was bustling.

By land or by sea, Narragansett delivered. It shipped its beer on boats, due to its proximity to the coastline, much like the early settlers did. From the docks in Narragansett Bay, its beer went all over the world to foreign ports in Panama, the West Indies, Turkey and Egypt. When it came to land, lucky for the brewery, a rail line abutted the brewery, and there were refrigerated cars that could deliver its beer along stops on the NYC/New Haven/Hartford line.

Beer and baseball go hand in hand on a hot summer night, so it's no wonder that Narragansett partnered up with several local baseball teams, including the local team the Providence Grays, the Boston Americans (better

Greg and Ed Theberge Collection.

known today as the Red Sox) and the Nationals (the Braves). The affiliation between Narragansett and baseball would continue for decades to come, but something came up that put the brewery on a hiatus for nearly a decade.

**Note: Stuffies, also known as quahogs, are an iconic Rhode Island dish of a clam stuffed with a mixture of bread, spices, chopped onion and celery and topped with lemon juice.*

A Busy Time

These are just a handful of the breweries that came and went during the early days before Prohibition. Eagle Brewing Company brewed a Red Star Ale in the years leading up to the "Noble Experiment," and Park Brewing Company was producing beer over near Roger Williams Park. Interestingly enough, after Park closed in 1913, it became the Eastern Film Company, where some of the nation's first silent films were made.

Opened in 1873, Eagle Brewing operated at the junction of West Exchange, Ames and Spruce Streets in Providence. *Greg and Ed Theberge Collection.*

We like to imagine author and Providence resident H.P. Lovecraft deciding whether he wants to drink a Hanley Peerless or a Providence Brewing Bohemian while penning his weird tales, but Lovecraft was an avid stick in the mud, stating that he could "see no justification whatsoever for the tolerance of such a degrading demon as drink."

Scattered accounts remain of other operations—mostly broken bottles and vague land sales accounts. Tales tell of a brewery in Newport around the time of the Civil War. A discovered bottle label marked "Crescent Park Boyden's Extra Table Beer" suggests the possibility of a brewery in Riverside's Crescent Park—or, as it was known, the "Coney Island of the East." Our imaginations stretch again, envisioning a brewery amid the Midway rides and roller coasters of the turn-of-the-century amusement park.

After World War I ended, the temperance movement reached a fever pitch across the United States. When the Eighteenth Amendment—which made production, importation, exportation and sale of alcohol illegal—went into effect on January 16, 1920, brewing came to a screeching halt.

CHAPTER 2

PARTY FOUL

PROHIBITION

If you look back throughout history, it is clear that alcohol has always been an integral part of society. New England farming families kept a barrel of hard cider by the door to satiate workers after a day in the fields. By the 1800s, rum, whiskey and other distillates were becoming increasingly available, and that's when things began to turn sour. A farmer would often have a beer with every meal, usually one low in alcohol. When farmers began to grow corn and wheat, producing harder spirits, people began substituting that glass of beer for a glass of whiskey or rum. It took society a bit of time to realize that a cup of hard liquor with dinner doesn't paint the charming pastoral image we all envisioned. By 1830, the average American was drinking eighty-eight bottles of whiskey per year.

TEMPERANCE AND RHODE ISLAND

The first stirrings of a temperance movement in Rhode Island came from the Protestant community during the 1820s and 1830s. Public drunkenness was becoming a problem, along with domestic incidents and abuse. Because of this, it's no wonder that women put themselves at the center of the temperance movement. For many women, the fight against alcohol was a fight to save their families, their communities and their husbands, as well as to protect themselves. Temperance and women's

rights became linked, and alcohol was essentially used as a scapegoat for many other societal failures. Alcohol was viewed as the root of all evils, and people claimed that if you didn't have alcohol, you wouldn't have domestic violence, prostitution or poverty.

Rhode Islanders began to rally around this cause, and groups began to organize in the state such as the Providence Temperance Union and the Providence Association for the Promotion of Temperance, with the first public temperance meeting held in Providence in April 1827. Pressure from these groups resulted in the Rhode Island legislature's passage of the state's first prohibitory law in 1852. A "Maine Law," so named because Maine was the first state to pass anti-alcohol legislation, made illegal the sale and consumption of liquor. Alcohol, commonly whiskey, was considered by some a medical treatment, and many medicines of the time contained a large amount of distillate. In many places, alcohol for medicinal purposes was still permitted, so physicians found a loophole and were writing boozy prescriptions to boost their income. Soon it seemed like every shop keep had become a pharmacist on the side. Rhode Island enforced a pretty drastic prohibitory law between 1874 and 1875, where even medical prescriptions containing alcohol couldn't be refilled. The chief enforcement officer under the 1885 prohibition law, which prohibited the sale of alcohol throughout the state, was Charles R. Brayton, known as the boss of Rhode Island in part due to his position as chairman of the Republican State Committee and, later, the "Blind Boss of Rhode Island" after his cataract-induced sight loss.

As it was in most other states, the law didn't stick. Brayton himself called the law "unenforceable," and it was repealed in 1888, although many towns, including Warwick, would pass local option laws to appease the prohibitionists in which counties could vote to be wet or dry. The temperance movement began to be overshadowed by the antislavery movement and the Civil War. With the Civil War raging, it is important to mention that one-third of the federal budget came from taxing alcohol. Temperance society membership dwindled.

It's easy to get on board with an ideology that is looking to protect women and children, as well as the general health and safety of the public, but what can't be overlooked is the anti-Catholic and anti-immigrant undertones that were also part of the temperance movement. Protestants were increasingly anxious over the rising number of Irish Catholics arriving in Rhode Island during the 1830s. After the Civil War, there was a large immigrant influx of Germans, Italians and Irish who were eager to start new lives but unwilling to give up their drinking culture. These cultures saw little wrong with

enjoying a brew every once in a while, and German immigrants created the huge beer companies we love to hate today (Schlitz, Pabst and Anheuser). As mentioned earlier, in 1888, six German American businessmen established Narragansett Brewing Company, Rhode Island's largest brewery. The United States Brewers Association conducted its meetings in German. Rhode Island even had to establish two separate brewery workers' unions since Local No. 114 was mostly German, and this created difficulty when employees from the Irish-based James Hanley Brewing Company sought to join. Alarmed by the steady increase in beer drinking and the German influence, temperance movements began to flare up again.

Larger organizations sprung up—the Woman's Christian Temperance Union (WCTU), Rhode Island Prohibition Party and the Rhode Island Anti-Saloon League. The WCTU of Rhode Island was an official branch of National Woman's Christian Temperance Union, whose purpose, as stated, was to encourage "political and social progress to correct rampant evils which were mostly drink associated." Officially incorporated in 1883 by the state, the organization grew rapidly, spawning nearly 120 local unions and giving weight to its assertion that "every town" in Rhode Island was "enrolled in our work." On the national level, anti-alcohol indoctrination even moved itself into schools, with students attending temperance classes multiple times a week. Their literature usually amounted to nothing more than scare tactics, even linking alcohol to spontaneous combustion.

At its peak, the WCTU of Rhode Island had 3,000 members and a newspaper, *The Outlook*, which had 2,500 subscribers. In the late 1800s, the WCTU began erecting drinking fountains in towns across the country so that men could get a drink of water without entering a saloon and staying for anything stronger. In fact, a cast-iron fountain built in 1898 still exists today on Block Island, serving as a symbol of abstinence, which has always had a strong foothold on the island. In an ironic twist, though, what the group thought was a biblical representation of Rebecca at the well turned out to be Hebe, a Greek goddess of youth and spring and the wine-bearer to the gods.

Prohibition Comes to Rhode Island

"If ever there was a state that gleefully thumbed its nose at Prohibition, it was Rhode Island," a reporter wrote.

The WCTU, while hugely important in the push for national temperance, was eventually pushed to the side with the rise of the Anti-Saloon League. While other groups had multiple goals in mind alongside banning alcohol, the sole purpose of the Anti-Saloon League was prohibition. The organization modeled itself like a corporation, complete with national headquarters, staff and financing from membership dues and church collections. Members believed that alcohol was being pushed on consumers and that if you simply eliminated this pusher, the problem would be squelched—they also believed that people were naturally temperate. Like most other prohibition advocates of the time, they failed to see the difference between alcohol and alcoholism.

The result of their government pressure was seen on January 16, 1919, at 5:32 p.m., when Utah became thirty-sixth of the forty-eight states then in the Union to ratify the Eighteenth Amendment, which placed a nationwide ban on all alcoholic beverages. This would remain law of the land for the next thirteen years. The only two states not to ratify were Rhode Island and Connecticut,

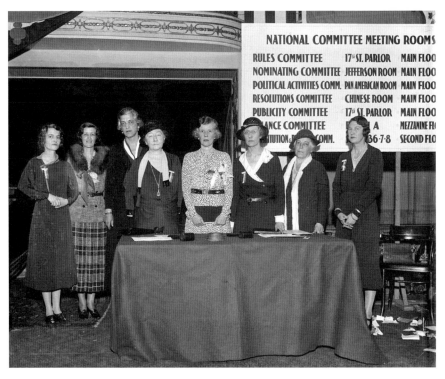

Maude Wetmore of Rhode Island (fourth from the left) served as the national vice-chairman for the Women's Organization for National Prohibition Reform. *Library of Congress LC-DIG-hec-36784.*

establishing Rhode Island's position as one of the most anti-Prohibition states in the country. Not only did the Democrats and anti-temperance Republicans in the legislature vote against ratification, but they also instructed the state's attorney general to constantly challenge its legality.

With the passing of the amendment, the state saw the closure of many of its operating breweries. Eagle Brewing Company, Providence Brewing Company and Consumer's all shut their doors in 1919–20. The James Hanley Brewing Co. survived with the production of a near beer known as "Limited." The Narragansett Brewery took its 'Gansett pilsner and made it into a near beer, dubbing it the "New Brew with the Old Name," with an ABV of less than 0.5 percent alcohol. 'Gansett had many of its bases covered when it came to staying operational during the Prohibition era. It made a line of sodas, including a ginger ale, sarsaparilla and a root beer, and produced artificial ice, as well as a malt tonic that boasted a low ABV and was sold for medicinal purposes. The brewery even underwent large improvements and alterations during the last years of Prohibition, becoming the largest New England brewery.

Since the Eighteenth Amendment didn't define what an "intoxicating liquor" was or provide means of penalizing transgressors, the National Prohibition Act, also known as the Volstead Act, was enacted, thanks to our friends at the Anti-Saloon League, as a way to enforce the amendment.

After a Severe Illness

the vitality of the patient is at its lowest ebb. The question of nourishment then becomes of greatest importance. ¶ The vitality must be built up, the blood must be enriched, new life must flow into the wasted tissues until the danger of relapse has passed. In this crisis

Narragansett

Malt Extract

is Nature's best aid. It is as refreshing as sleep to the tired body and nerves—as invigorating as deep breaths of pure, fresh air to the sluggish, impoverished blood.

**For Sale
by Most Druggists**

Insist on the original Narragansett. Guaranteed under the National Pure Food Law, United States Serial Number 4251.

NARRAGANSETT BREWING COMPANY
Providence, R. I.

Beer as a health tonic—sure beats snake oil. *Greg and Ed Theberge Collection.*

What Prohibition essentially did was turn once legitimate businesspeople into criminals and fatten the pockets of gangs, which often took over the production and distribution of beer and spirits.

Many chapters of the Anti-Saloon League began hiring private detectives to gather evidence of illegal liquor sales. These detectives were able to infiltrate saloons more surreptitiously than the average temperance worker but would eventually begin to raise problems for the league. For one, they were quite expensive, and the general public also wasn't too keen on using these sneaky tactics to bust their neighborhood speakeasies. Members of one Rhode Island jury announced that they would rather "rot in their chairs before they would find a verdict of guilty on 'spotter' evidence."

With four hundred miles of open coastline, Rhode Island became a haven for rumrunners, who smuggled in liquor from Canada and the Bahamas using high-speed boats. It's reported that Al Capone traveled to Rhode Island in 1928 in the hopes of making a supply connection with the smugglers. When three rumrunners were killed by the Coast Guard in 1929, Reverend Roy W. Magoun told his congregation at St. George's Church in Newport, "The deaths of these men must bring to us a little more clearly the horrible price we are paying in attempting to enforce laws which are fundamentally un-American and un-Christian."

At the time, Rhode Island was one of the most Catholic states in the country—76 percent to be exact—as well as one of the most urban. People felt the strong anti-Catholic overtones of the temperance movement and saw the law as an attempt to impose rural Victorian values on their increasingly diverse and growing cities. In many states, Prohibition was embraced by people anxious about the increasing immigrant population and the drinking cultures that they brought with them. In one Federal Hill district, with its large population of Italian immigrants, the vote against Prohibition was 2,005 to 3. In 1930, Rhode Island state legislators voted for a repeal of Prohibition, with the results showing 172,454 voting for the repeal and only 48,540 voting against. Cities including Providence, Pawtucket, Woonsocket and Newport continued as hotbeds of anti-Prohibition sentiment, and lawmakers continuously challenged Prohibition laws in court.

By this point in urban areas, alcohol consumption was largely tolerated, and speakeasies were a way of life. Providence federal agents would mingle with citizens looking for a drink at Marconi's Roman Garden on Bradford Street in Federal Hill. Wine flowed at one dollar per bottle, and scotch, rye and gin were free of charge to agents. In Newport, politicians imbibed at The Mission, a speakeasy on West Broadway owned by Billy Goode where

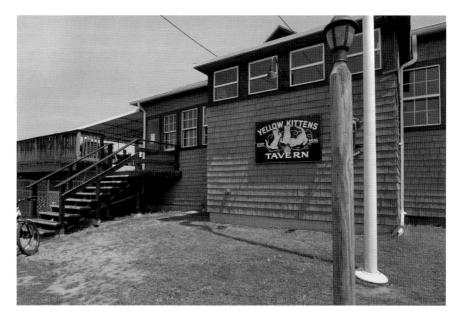

Yellow Kittens, which opened in 1876, has been a Block Island fixture before, during and after Prohibition. *Kristie Martin.*

you could buy a bottle of homebrew for fifteen cents. Goode wound up being the first Rhode Islander arrested for running a speakeasy. Woonsocket was known as the city of "mills and stills," and drinkers flocked to Block Island to drink at the Yellow Kittens until its bust in 1925. Yellow Kittens, and its adorably named patio restaurant, Los Gatitos, is still operating if you're looking to imbibe at Block Island's oldest bar. Warwick became notorious for its speakeasies throughout Oakland Beach, Pawtuxet and Apponaug, and as a result, organized crime gained a strong foothold.

> *"Mother's in the kitchen Washing out the jugs; Sister's in the pantry Bottling the suds; Father's in the cellar Mixing up the hops; Johnny's on the front porch Watching for the cops."*
> —*poem by a New York state rotary club member during Prohibition*

Malt and hop stores emerged across the state. Soon every grocery was selling malt extracts for "baking purposes." Beer was brewed in secret, down in cellars or behind kitchen stoves. The Hand Brewery, as previously noted, was the only Rhode Island brewery to openly snub Prohibition and produce full-strength beer, but overall, the beer industry was dead. Operating a

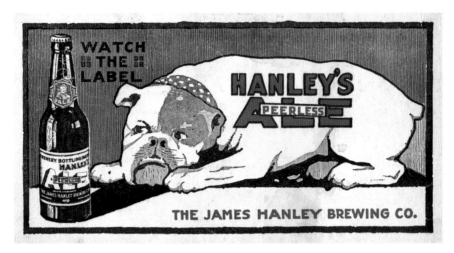

Known as the "Watchdog of Quality," this recognizable bulldog became the Hanley mascot after the repeal of Prohibition in 1933. *Greg and Ed Theberge Collection.*

brewery in secret is no easy feat, and since beer was the weakest alcoholic beverage, bootleggers favored rum and whiskey, essentially turning the country away from beer and once again into a nation of hard drinkers. This was the opposite of what the movement set out to do.

Finally, on December 5, 1933, after the movement had lost popular support and cost the government billions in lost tax revenue, the Twenty-first Amendment to the Constitution was ratified.

The Post-Prohibition Landscape

Prohibition seriously dampened the brewery scene for just over a decade, but a few breweries tried to give it a go afterward. The Warwick Brewing Company produced beer in Natick between 1933 and 1936. In Olneyville, Roger Williams Brewing was brewing a pale ale, lager, porter, cream ale and an India pale ale, calling itself the "Beer of Good Cheer." Consumer's, later to become Hollen Brewing Company, operated in the Hillsgrove part of Warwick. With its father figure mascot and motto to "Ask Father," you would think a brewery would learn that the image of a stately older gentleman isn't going to send your beer flying out the door; they closed up shop in 1938.

Across the country, small breweries were realizing that the beer landscape of post-Prohibition America was changing. After the introduction of the beer can in 1935, people were buying in bulk from stores rather than on draft at their neighborhood saloon, although not every brewery could afford a canning line. Improvements to rail transportation and the advent of refrigerated trucks allowed big breweries to ship their beer farther and with less impact on quality. Couple that with the rise of television and its effect on product recognition and brand loyalty, and it's easy to see how a few large companies came to dominate the beer world.

Although Hanley's was able to survive the Prohibition transition and create a successful local brand, there was one Rhode Island brewery that came to dominate the New England beer scene for most of the twentieth century.

HAVE A 'GANSETT!

Narragansett found other ways to survive, but that's all it was doing—surviving. Those years were lean for the brewery, and it became harder for it to keep its head above water. By the twilight years of Prohibition, the equipment and grounds of its once state-of-the-art brewery were becoming dated, but the brewery could not find the money required for modernization. Profits had been on a steady decline throughout Prohibition, and Narragansett knew that it would need help to restore the brewery to its former self.

In 1931, near the end of Prohibition, Narragansett asked Rhode Island industrialist philanthropist Rudolf F. Haffenreffer Jr. to fund and manage its brewery. Haffenreffer agreed, and as Prohibition came to an end in 1933, he began to turn 'Gansett into the brewing powerhouse it once was.

Haffenreffer was no stranger to the beer industry. His father, German immigrant Rudolf F. Haffenreffer, was a brewer and headed Haffenreffer Brewing Co. from 1870 to 1929. It was fitting that his son would head one of the United States' largest breweries.

Haffenreffer Jr. became the chairman and president of the board of directors, and by 1936, the brewery was back on track and leading the way in innovation. Its once state-of-the-art bottling line was supplemented with a canning line. Cans were a new technology, and Narragansett was one of the first to can on-site. Haffenreffer not only advanced the brand technologically, but he also worked on updating the iconic image. Haffenreffer, a serious collector of art and American Indian artifacts, collaborated with an artist friend of his son's from Dartmouth College, a young man named Theodore Geisel (known to most as Dr. Seuss), to develop new ads for the beer. Perhaps the most iconic of these ads is the 1941 "Chief Gansett," the lovechild between Seuss's creative eye and Haffenreffer's love for cigar store Indians. This mascot has withstood the test of time, and both beer and Seuss collectors today vie for Chief Gansett merchandise in online auctions and at antique stores.

Narragansett supported baseball in its early years, and now that it was back and bigger than before, it took up these sponsorships again. It became a sponsor of the Boston Red Sox and the Braves radio broadcasts in 1947. The Braves became sponsored by P. Ballantine & Sons in 1950, but Narragansett continued to do Red Sox TV and radio for more than twenty years, launching 'Gansett to "household name" status throughout New England. Nearly every New Englander of that era still remembers Curt Gowdy, voice of the Red Sox, talking about the "straight from the barrel taste" and calling out the slogan, "Hi, Neighbor! Have a 'Gansett!"

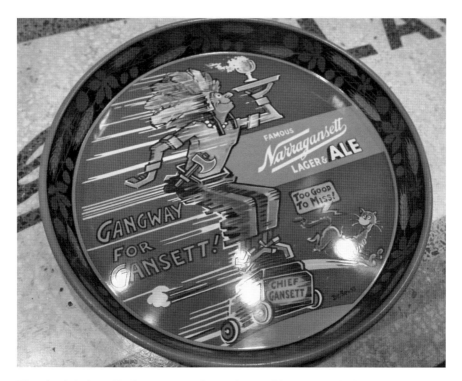

Theodor Geisel, or "Dr. Seuss," comes from a family of brewers; his family opened the Kalmbach and Geisel Brewery in 1876, known to locals as the "come back and guzzle" brewery. *Greg and Ed Theberge Collection.*

These were Narragansett's golden years, and when Haffenreffer passed away on October 10, 1954, his sons, Rudolf Haffenreffer III (president) and Carl Haffenreffer (vice-president), took over. They continued to lead Narragansett toward success. In 1957, the two brothers bought out the Hanley Brewing Company of Providence, which made Narragansett the only brewery in Rhode Island at the time. Continuing their expansion north, they also bought out the rights to Haffenreffer and Croft Brewing Companies of Boston, Enterprise Brewing Co. in neighboring Fall River and Kruger Brewing Co. in New Jersey. Narragansett was unstoppable, and in 1959, it produced 1 million barrels of beer, giving employees a gold-plated bottle of beer.

In the 1960s, Narragansett accounted for 65 percent of all beer sold in New England and had solidified its presence in the area. In addition to the Red Sox, Narragansett was also promoted by its "Hi Neighbor" girls, who looked beautiful and promoted goodwill and 'Gansett throughout New England by riding on parade floats, leading brewery tours, making store

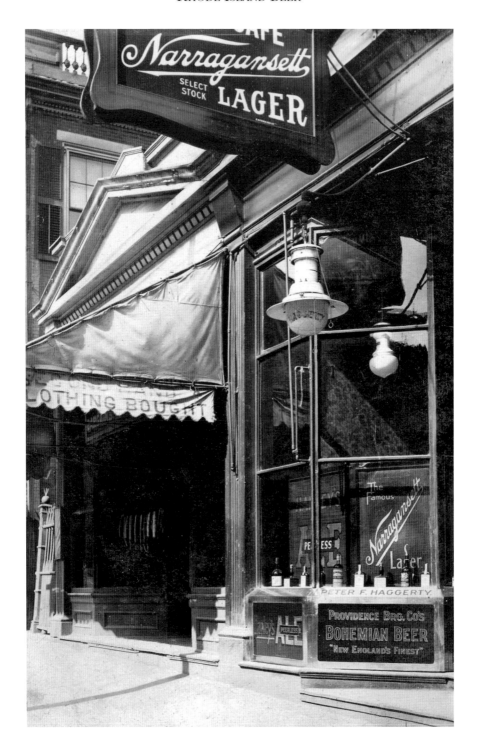

Above: Curt Gowdy, the "voice" of the Boston Red Sox, makes a toast with 'Gansett. *Greg and Ed Theberge Collection.*

Opposite: A pre-Prohibition shop window showcasing Narragansett, Hanley's and Providence Brewing Co. *Greg and Ed Theberge Collection.*

appearances and showing up at local events as the "face of Narragansett." The original "Miss Hi Neighbor" was Irene Hennessy.

But nothing gold can stay, and on July 15, 1965, Narragansett was sold to the Falstaff Brewing Co. in St. Louis, Missouri, for $17 million and $2 million of Falstaff common stock. In a sense, Narragansett had left Rhode Island. F&M Schaeffer Brewing replaced 'Gansett as a Red Sox sponsor, and its slow decline began.

Although no longer Rhode Island–owned, Narragansett still maintained a local presence and hosted the Gansett Tribal Rock Festival at Boston Garden, with Led Zeppelin in 1969 and Crosby, Stills, Nash and Young in 1971. It was also a sponsor of the famous Newport Folk Festival with Bob Dylan. In 1972, Narragansett was producing 1.7 million barrels of beer annually. Narragansett got another boost when the 1975 hit movie *Jaws* featured Captain Quint "crushing" a can of 'Gansett. This iconic design was reintroduced in 2012 with the "Crush it like Quint" contest.

Falstaff, the parent company of Narragansett, was bought out and relocated to San Francisco. With this, F&M Schaeffer Brewing had replaced 'Gansett as a Red Sox sponsor. Production moved to Indiana, which led to layoffs and a decline in the overall quality of the beer. The brewery closed

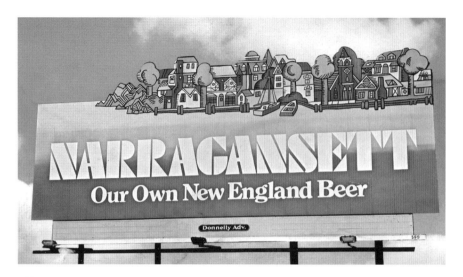

This Narragansett billboard screams 1970s. *Greg and Ed Theberge Collection.*

its doors in 1981, and in 1998, demolition began. The Cranston Municipal Courthouse and the Sanford-Brown Institute were built on the former brewery site, and in 2005, the Trolley Barn, slated for redevelopment, was knocked down. The Brewery Parkade retail plaza had replaced what was once New England's largest brewery. Narragansett, a Rhode Island icon, was no more. As Narragansett fell from its former glory in the 1980s, so did beer across the country. With a few key companies controlling the beverage industry, beer becomes a product rather than a recipe, and uniformity ruled over flavor.

A LOCAL BEER RENAISSANCE

The bleak landscape finally began to shift in the late '70s and early '80s. In 1978, an innocuous House resolution was signed by Jimmy Carter that amended excise taxes on trucks, buses and tractors. Tucked away in this resolution was a law giving homebrewers the right to brew up to one hundred gallons of beer per year for personal consumption. Since most professional brewers were probably at one point in time brewing at home, this was a big deal. Brewing pioneers like Fritz Maytag of Anchor Brewing Company and Ken Grossman of Sierra Nevada, along with many others, began to show

the world that American beer was more than just light lagers. According to Andy Crouch in his book *The Good Beer Guide to New England*, there were five hundred breweries operating in the United States during the 1990s, with an average of three to four opening each week. By 1996, the number had doubled to more than one thousand.

HOPE BREWING

In February 1988, Hope Brewing Corporation opened its doors, marking Hope Lager as Rhode Island's first beer since Narragansett's closure seven years earlier. Banking on state loyalty and a renewed nationwide interest in local microbrews, Hope sought to put Rhode Island beer back on the map. "It wasn't that long ago when seven of every ten beers consumed in Rhode Island, and nearly half of all the beer consumed in New England, were Narragansetts brewed in Cranston," said company CEO Richard Fensterer.

With ex-Anchor brewer Timothy Morse at the helm, Hope began to make a name for itself with its Hope Lager, described as an amber-colored, full-bodied brew, slightly bitter and with a stronger, hoppier flavor than most domestic beers. Following strict Reinheitsgebot standards (the German beer purity law specifying that the only ingredients used in beer be water, hops, yeast and malt), Hope Lager went on to win third-best European-style pilsner at the Great American Beer Fest.

Hope products were available throughout New England, running for about $4.25 for a six-pack. The company even found itself running out of beer during the first few months, with demand for the beer far exceeding its initial supply. But the reason why we're not hoisting the Hope Brewing flag into the beer hall of fame is because, well, the brewery with the Rhode Island state motto was never brewed in Rhode Island. It was contract-brewed at the Lion brewery in Wilkes-Barre, Pennsylvania. A seventy-thousand-square-foot building owned by the company and in need of extensive remodeling sat unused on Providence's Elmwood Avenue. Brewery equipment was bought from a former Molson brewery in Canada, although it remained in Canada. Hope received preliminary approval for $2.5 million in state-guaranteed bonds, although it was promised on the condition that Hope could raise the additional $2.25 million needed to renovate the brewery. Hope was never brought home to Rhode Island and closed in the early 1990s. Timothy Morse moved on to Boston's Commonwealth Brewery, later becoming a founding brewer of the John Harvard chain.

EMERALD ISLE BREW WORKS

Warwick dentist Ray McConnell spent some years abroad in the military. Upon returning home, he realized that no American beer came close to what he had been drinking in Germany. Local beer was virtually nonexistent, and so, with no one to lean on and no easily accessible supply shops, McConnell reached out to a friend in England who mailed him grains, hops and dry yeast. The science of brewing came easy, but the technique was a different story. After many failed batches and the realization that sanitation was a crucial step, McConnell launched Emerald Isle Brew Works, one of the first cask-conditioned breweries in the country.

What is cask beer, you may ask? Cask-conditioned, or "real ale," is unfiltered and unpasteurized beer, usually served from a small wooden barrel, known as a firkin, without any additional nitrogen or carbon dioxide. The beer is dispensed by means of a beer engine or hand pump, which acts as a siphon. Why specialize in such a niche beer style? McConnell noted that in the early '90s, beer was not the same commodity that it is today. People were just beginning to recognize that there were worlds of styles and flavors outside the pale lager, and what better way to get Americans educated on what real beer is than by producing beer in its most authentic form?

Emerald Isle's flagship brew was the Bank Street Ale, an example of an English bitter, remembered for its balanced bitterness and rich quality. Patrons of Aiden's Pub in Bristol were taken back to a colonial-like experience, watching the bartender hand-pull fresh beer straight from the barrel. Emerald Isle went on to produce an India pale ale, a porter and Emerald Isle Ale, known as a sweet brown ale with notes of caramel and a perfectly balanced Cascade and East Kent Golding hop profile. This beer, unlike the other cask ales, was served through European taps, similar to Guinness, using a blend of nitrogen and carbon dioxide.

For a garage-sized brewery making about two hundred barrels per year, and with Ray having to persuade bars into leasing a beer engine, it was a wonder that Emerald Isle's distribution spread. From Newport's Wharf Pub to the Blind Tiger in New York City, people could not get enough of the real ale. With the help of his son, Michael, Ray received favorable responses at the Great British Beer Festival, where his was one of only a small number of American beers served.

After dealing with mounting frustrations and red tape involved in taking the brewery to the next level, McConnell was faced with the sad realization that an ingenious startup like Emerald Isle was ahead of its time. A brewpub had always been his goal, and it seemed the logical

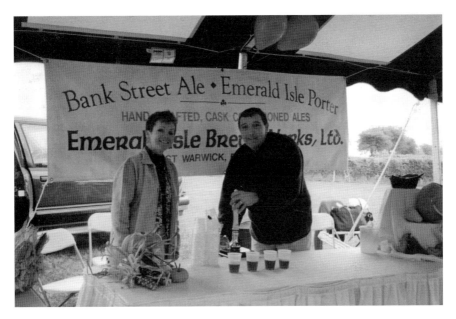

Ray McConnell of Emerald Isle Brew Works serving up some real ale. *Ray McConnell.*

plan for a brewery whose product involved a large commitment from retailers. Emerald Isle was essentially a beer made out of passion, as Ray still worked full time as a dentist. In 1999, after receiving a less-than-favorable response at town meetings. McConnell withdrew his brewpub request and shut down all brewing operations.

Today, you'll find all of Emerald Isle's old equipment at the Kennebec River Brewery, part of Maine's Northern Outdoors Resort, where Michael McConnell works as a brewer. As for Ray McConnell, you'll find him and his wife up in Damariscotta, Maine, running Alewives & Ales Bed and Breakfast. Ray still operates a small home brewery for people looking to experience a bit of Rhode Island brewing history.

THE RISE AND FALL OF RHODE ISLAND CRAFT

Although breweries like Hope and Emerald Isle were able to experience some success, their situations were similar to many upstart breweries across the country. Throughout the 1990s, people with little to no brewing or business experience began to open up breweries. Some may remember the

story of the Great Providence Brewing Company. Started in the late '90s by Fred Argilagos and Greg Hutchins, Great Providence's pilsner was deemed the official beer of Providence by Mayor Buddy Cianci, was supposedly being shipped to Hong Kong as part of a Chinese unification ceremony and was going to be the product to bring brewing back to the Ocean State—all before one bottle of it was actually brewed. Although some say that the pilot batches contract-brewed in Pennsylvania by former Trinity Brewhouse brewer Kurt Musselman were quite exceptional, it didn't make up for the fact that it was an idea without the backing capital, and Kickstarter was still a long ways off. Beer author Andy Crouch likened these volatile beer years to the dot-com days. He noted that by 1998, brewery openings and closings nearly equaled each other, leading to an immense shakeout.

The Brewpubs

Prohibition was declared a failure, but the effects were long felt. Pre-Prohibition, many bar owners were essentially front men for larger breweries. A bar would serve one brand of beer, whether it be Narragansett or Hanley's, and the brewery would, in many cases, provide everything the bar needed to operate, from pint glasses to interior decorating. Bars would lure customers in with offers of free lunches. All of this helped to fuel the rowdy saloon life that sparked the prohibitionists in the first place. To prevent this from happening again, a three-tiered system was established. Beer and liquor producers were banned from selling directly to the bar or consumer and, instead, had to go through a middleman, the distributor.

Distribution usually comes down to volume, especially in the late twentieth century. In her book *Crafty Bastards*, Lauren Clark remarked that "very few wholesalers thought it worthwhile to tack a few cases of an unknown brand onto their Bud, Miller, and Coors-dominated portfolios. In order to bring their product to market, microbrewers would have to distribute it themselves." Enter the brewpub—brew and sell your beer all from the same building and cut out the middleman altogether. Good food and good beer go hand in hand, and this is where brewpubs come into play. There's something enticing about going to a brewpub, wondering what will be on tap or what creative new small batches they may have come up with, all while the signature smell of malts lingers in the air.

The '90s were a pivotal time for beer in Rhode Island. While breweries may have come and gone, surprisingly, all of Rhode Island's brewpubs have

stayed the course, developing loyal followers through offering quality beer and food accompaniments or enticing beer aficionados with a brewpub staple: the mug club.

But what makes a brewpub different from a brewery? A brewery sells most of its beer off-site, at bars and liquor stores; meanwhile, at a brewpub, all of the beer is brewed and sold on-site. On July 7, 1997, Governor Lincoln Almond passed the "Brewpub Bill," giving establishments that produce beer for on-premise consumption the right to sell their beer through a distributor to off-premise accounts, as opposed to just on-premise growlers. While Rhode Island wouldn't see another production brewery until 1999, the state was ahead of the game when it came to on-site brewing, boasting some of New England's first brewpubs and helping lead the state into the active beer scene we know today.

Union Station Brewery

36 Exchange Terrace, Providence, 401-274-2739
www.johnharvards.com
Opened in 1993

Let's just get it out in the open. Yes, John Harvard's is a chain of brewpubs not entirely known for its brewing innovation. Some people probably envision a loud, sports bar–esque monstrosity, pumping out watered-down blonde ales and nachos for the masses, but Providence's Union Station is not that bar.

The original Union Station, which was opened in 1847, is remembered as a beautiful example of Romanesque architecture, as well as the longest building in America. Rail travel was at a peak, and Union Station served to connect the thriving city with other major East Coast destinations until the building suffered a devastating fire in 1896. The poor station would be smote with flames yet again in 1987. The Providence Chamber of Commerce sponsored investors to help renovate the site, and in 1993, the building's lower level opened as Union Station Brewery.

The brewery itself is nestled down a flight of stairs between Providence's Exchange Street and Waterplace Park. Dark wood and exposed brick create a spacious and warm interior, with pictures of vintage brewing equipment lining the walls, reminding you that Providence is a place where a lot of modern brewing has its origins. With new breweries opening up monthly, it's

easy to forget that there was a time when Union Station was winning awards for its beer. Between 1993 and 1996, the brewery took home "Best Bar" and "Best Place to Go for Beer" from *Rhode Island Monthly* magazine, and in 2012, Northern Light took second place in the Golden Ale category at the Great International Beer Competition. Bottles of Union Station's Premium Red Ale could also be found at various spots throughout the state, but that beer was brewed under contract by Oldenberg Brewery in Kentucky, thereby bypassing the Rhode Island General Law, which stated:

> *Not more than one retail license, except in the case of a retailer's Class E license, shall be issued for the same premises. Every license shall particularly describe the place where the rights under the license are to be exercised and beverages shall not be manufactured or kept for sale or sold by any licensee except at the place described in his or her license.*

Translation: If you're a liquor store, you can sell beer as long as it's not consumed on-site. If you're a brewpub, you can make beer, but you can only drink it there. And if you're a brewery, you can brew beer, but you have to sell it through a distributor (see the Rhode Island Brewers Guild section for more on how beer laws have changed in the state).

The brewpub has seen its share of talented brewers throughout the years, including Gary "Goose" Gosselin, who left after the John Harvard merger in 1995 and went to open up Brunswick Barbeque and Brew in New York, as well as brewer Norm Allaire, previously of Providence's Hope Brewing; Aaron Crossett; and, currently, Robert DaRosa. After receiving a winemaking kit for Christmas, DaRosa turned his attention to beer, realizing that he could have a finished product in weeks instead of months. Starting at Union Station as a server, DaRosa drew the attention of then head brewer Aaron Crossett. After two years of apprenticeship, DaRosa did what most homebrewers only dream of and took over the ten-barrel brewhouse as head brewer. Although he's required to produce a certain range of categories (light, pale, IPA, red and dark), DaRosa has free rein over his beers, and the brewery will see several adaptations of each style over the year. Unlike many breweries, Union Station doesn't have a hop contract sealing it to one supplier, so DaRosa seeks out unique high-end hops for his beers. A Hop Mess features Simcoe, Galaxy, Nelson and Mosaic hops, along with sixty pounds of honey.

Union is continuously releasing new beers alongside old favorites, with most beers being in the 5 to 6 percent alcohol range, making them accessible

to beer newcomers. Some tap list highlights include the Wicked Pale Ale, an award-winning hoppy golden ale brewed with caramel malts and Cascade hops, and the Cascadian Ale, showcasing the toasted and chocolaty character of roasted barley alongside the piney bitterness of Cascade hops. A Union Station flight will take you through light lagers, fruit-based wheat beers, a variety of hoppy offerings and some darker beers, like its Vanilla Bean Porter or the Lights Out Stout. "We want to please everyone's palate and let them experience beer at its freshest," said DaRosa.

The food at Union Station goes the safe route of American pub fare, but don't let that dissuade you from paying it a visit for dinner. Appetizers include house-made pretzels with a smoked gouda beer sauce and braised pork tacos made with beer-braised pork, tomatillo sauce, radishes and fried onion strings. The sandwiches and entrées are comfort food at its best. Try a Creole Cuban, with slow-roasted pork loin, ham and remoulade on a baguette, plus a side of the roasted sweet potato wedges.

The crowd at Union Station, most drinking out of their own mug club steins, seems to recognize and appreciate the personal touches that the Union Station staff brings to the beer and the food. "I rarely drink the beer I brew," DaRosa said, laughing. "I'm constantly trying new things, looking to expand what I know. It helps broaden your horizon."

TRINITY BREWHOUSE

186 Fountain Street, Providence, 401-453-2337
www.trinitybrewhouse.com
Opened in 1995

Women arm wrestling in the ladies' room or drinking a beer under the watchful gaze of Biggie Smalls is just a part of the Trinity Brewhouse experience. This Providence brewpub, adorned with murals, has a creative and constantly changing offering of beers, along with a mug club, cheap wings, trivia and all of the other accoutrements that make a brewpub a success.

Trinity was started in 1995 with brewer Kurt Musselman. He had a degree in food science from the University of Rhode Island (URI), worked with Harpoon Brewery and had done consulting work for a brewing systems company. After Musselman left, Sean Larkin took over as head brewer in August 1996 after training for a year. Following Larkin's departure in 2014,

Tommy Tainsh became head brewer. Tommy was a chef at a restaurant that was bought out by a corporate company, and after working ninety hours a week and not liking the corporate atmosphere, he finally decided to take a summer off. Two weeks into that vacation, Sean called him to see if he could help him out at Trinity. Now, several years later, Tommy has brewed 900,000 gallons of beer, give or take a pint.

Trinity's beers are based on traditional styles of beer, with its benchmark characteristics of what each style should embody. Once these were established, the tweaking and customization began. Sean explained:

> *If they gave us three or four different versions of a pale ale recipe, we would see what was most common between the recipe and what was the most uncommon and then see if the uncommon things made any sense or whether it was something that disappeared depending on when the beer was brewed—meaning that some of these books would reference recipes from the 1700s and 1800s. So, historically, malts and malting practices got better as brewing science progressed. So we were trying to pick the parameters that made sense and expand on them a little bit.*

Their recipes are also inspired by everyday experiences. Tommy said that Redrum was inspired on the way to a Stevie Wonder concert in Boston. He tried an imperial red, fell in love with the malty, hopped-up beer and decided to try his hand at brewing something similar.

The U.S. hop market changed in the '90s and 2000s, and this influenced the way beer was brewed at Trinity. In the '90s, there weren't many hop varieties available, mainly just Cascade and Nugget. Then, in the late '90s, the boutique options of hops, such as Simcoe and Citra, started to pop up. Trinity could use as many hops as it wanted; however, in the late '90s, a warehouse fire in the Northwest led to a dearth of hops. This started the "contract revolution." Growers who used to have an open hop market instead wanted a guarantee that if they grew the hops, they would be purchased. This started the advent of contracts and price hikes, and if you played your contracts wrong, those were the only hops your brewery would be able to use. Trinity had to pull back a little bit, and in this time, the brewers were able to be as creative as they wanted with heavily malt-based recipes.

Trinity used these recipes to stay with its deep sense of traditionalism; however, it still pushed the boundaries of brewing. "We try to push style guidelines as much as it makes sense without compromising the integrity," Sean said. Its Belgian Strawberry, limited to two pints per person, is

Through the beer forest at Trinity Brewhouse. *Kristie Martin.*

fermented with more than three hundred pounds of strawberries, as well as being conditioned with strawberries. Tommy added:

> *Years ago, Sean and I were brewing a Belgian beer, and some of our equipment decided to kick, or something to that effect. So, we were joking around about what we should do with this beer. The hop crisis was in full*

*force at the time, so we were talking about throwing strawberries into it.
One joke led to another, and we did the Belgian Strawberry, 11 IBU and
12 percent ABV…This beer turned people into lunatics. We had to do
a two-pint maximum so people wouldn't hurt themselves. We fill tons of
growlers so people can enjoy the beer safely at home.*

Their ever-popular Trinity IPA is available in bottles in the Rhode Island
area. "The IPA was our flagship for years. If we ran out of IPA, it would
be the equivalent of taking candy away from a child," said Tommy. Rhode
Island state senator and Trinity owner Josh Miller chose Cottrell Brewing in
Connecticut to bottle the IPA.

Trinity keeps its kölsch, RI IPA and Tommy's Red on tap at all time, with
up to ten rotating beers available. Trinity has something for everyone, and
that's part of the pub's success. Tommy noted, "The crowd here is all over
the board. You could be a twenty-one-year-old dirt muffin hippie talking to a
sixty-five-year-old Brown professor. People from all walks of life are welcome
here. That's why so many people like it here. It's not like most places you
walk into and they eye you up and down to see if you're from out of town…
If you look at the banner over the pub, it shows a circus crowd, and it says,
'Everyone welcome'…that banner speaks volumes."

CODDINGTON BREWING COMPANY

210 Coddington Highway, Middletown, 401-847-6690
www.coddbrew.com
Opened in 1995

An air of nostalgia and hometown pride runs deep through Coddington.
It's the type of place where the bartender will remember you from months
before. It's the type of place where as you sit and look over the menu,
people stop by the bar to simply ask for growlers to go and chat with the
owner like it's part of their weekly routine. Giant bags of malted barley
line the room, as do photographs of Newport's past. The brewer stirs the
mash with a rowing oar passed down through generations. The locals
seem happy at this timeless American pub, and you notice the copper-clad
tanks through a dining room window and the refreshing fact that no one is
drinking Bud Light bottles.

Coddington has always been a family business. Before Billy Christy purchased the building from his father at the age of twenty-four, Coddington was The Lighthouse, a bar and restaurant serving mainly navy officers from the Newport Naval Station since the 1940s. Not a day goes by where you won't find Billy working at the restaurant, usually accompanied by his wife, Heidi, or his father, Dino. In 1999, Christy brought on brewer Marshall Righter, a graduate of the Siebel Institute in Chicago, the oldest brewing school in the country. Righter had previously worked at New Hampshire's Smuttynose and Portsmouth Brewery, as well as Boston Beer Works, before coming to Coddington, where he is a one-man operation in the seven-barrel brewing house.

Righter stirs in all his grains by hand in the small brewhouse, which can be up to 660 pounds of barley in the case of the Coddington barley wine. Most people think of barley wines as an American style, but in fact they have their origins in England and were later brought to America in the 1970s. Righter uses high fermentation temperatures to deliver fruity estery notes along with high alpha hops for the beer's crisp hop bitterness. At the end of the mash, all of the grains are collected, along with any restaurant food waste, and sent to local farmer Dave Rodriques to serve as cattle feed.

"We brew for our clientele," Righter said. A mix of locals, tourists and navy crew, the crowd at Coddington has a wide palette of beers from which to choose. As one of Rhode Island's first brewpubs, Coddington was there to usher in the national shift from corporate beer to a more local option. Christy recalled, "I got to see the transformation from Bud to craft and provide people with more choices." Order a sample tray, and you'll be presented with up to seven seven-ounce selections of beers currently on tap, a mix of seasonal and year-round offerings. Please note that we suggest bringing a friend, because forty-nine ounces of beer can get slightly overwhelming around that fifth little glass. At any time during the year, you'll find Coddington's Blueberry Blonde, a golden ale with a subtle blueberry flavor; a clean and well-balanced 5 percent IPA; its rich and traditional Irish stout; and the beer Righter is most proud of, the golden ale, which is a perfect beer for those looking to transition from the world of macro-lagers to craft. Coddington's tap list is constantly changing, with Righter brewing up to forty different styles of beer per year. Keep a look out for the Double Chocolate Oatmeal Porter, brewed with cacao nibs and chocolate malt, as well as the Winter Warmer, which gets its silky sweetness from the addition of sixty pounds of figs.

Coddington's is a way to experience local flavor without having to venture into the oftentimes crowded and expensive restaurant scene of downtown

Marshall Righter, brewmaster at Coddington Brewing Co. *Kristie Martin.*

Newport. If you're like us, you'll want to join its mug club, even if you're just vacationing on Aquidneck Island for the weekend. There's some sort of intrinsic urge to feel part of the exclusive club that drinks discounted beers from numbered ceramic mugs—or you can simply order a growler of your favorite beer to take home.

MOHEGAN CAFÉ AND BREWERY

213 Water Street, Block Island, 401-466-5911
www.moheganbi.com
Opened in 1998

Thirteen miles southward and out to sea lies Block Island—largely rural and a beachgoer's dream, with dramatic seaside cliffs resembling the coast of Ireland. There are no traffic lights or chain stores, and the tourists are easily recognized by their zippy scooters and Block Island sweatshirts. It's the

Kristie Martin.

place people visit for frozen mudslides by the beach or to live out a Jimmy Buffett song—not exactly the type of place envisioned as having its own brewery. But there it is, just a jump from the shore, in the first floor of the rustic Water Street Inn: Mohegan Café and Brewery.

Classic nautical décor dons the walls, giving the restaurant a cozy and family-friendly atmosphere. Staff members greet guests like they've been coming there for years. It's completely unpretentious and made us wonder why we don't make the ferry trip out here more often.

Although Mohegan Café opened in 1990 as a seafood restaurant and pub, it wasn't until 1998 that the beer started flowing. The story goes that former owner Mike Finnimore came in to work one day to discover employee Dave Sniffen cleaning his homebrew equipment. This sparked Finnimore's interest, and after battling local zoning and licensing issues, Mohegan Café was reborn in 1998 with a ten-barrel brewhouse and Sniffen at the helm. The only problem was water. Block Island depends on a limited supply of fresh water that is replenished only by rainfall. Caps exist on the amount of water that businesses can use. Usage is restricted, and large fines are in place for businesses that exceed the limit. These regulations restricted Mohegan's brewing capability, leaving extract brewing as the only option.

The typical all-grain brewing process involves a step called mashing, during which crushed malts are combined with hot water, converting starches into simple sugars. After mashing, hot water is added to the grains in several stages, extracting the sugars from the grain in a process called sparging. This produces the sweet liquid called wort, which is later boiled and fermented to become beer. Extract brewing uses concentrated malt extracts, which lets brewers skip the mashing and sparging step and move directly to the boil.

Malt extract is added straight to the brew pot and boiled with the hops to create the wort.

While the beers produced at Mohegan Café might not be brewed exactly to style, its unfiltered offerings are undeniably fresh and a welcome respite from the sea of macro offerings at other island bars. Its first and flagship beer is the Mohegan Pilsner, a light and refreshing take on a pils. The Striper English Ale is earthy with a hearty malt base, and the Chili Pepper Ale packs fresh pepper flavor without being overpowering and serves as a perfect beer to accompany a meal. Other offerings one might find are the Black Buck Porter, Honey Lemon Pilsner and the bock.

Sniffen is still at the brewery, now as head chef, and new owners Mark Scortino and Katie Simlick bring a fresh point of view to the established restaurant. The food is a mix of classic pub fare alongside some upscale seafood dishes. For an appetizer, try the ceviche, featuring scallops and shrimp tossed in fresh lime juice, or the fried calamari with hot pepper rings. Entrées range from burgers to pasta, with interesting and flavorful options thrown in like pad Thai and a blackened mahi mahi sandwich. Make sure you check the calendar before departing. Mohegan Café is closed between November and St. Patrick's Day.

BRUTOPIA BREWERY & KITCHEN

505 Atwood Avenue, Cranston, 401-464-8877
www.brutopiabrewery.com
Opened in 2014

Newest to the Rhode Island brewpub scene is Brutopia, part of the Sorbo Restaurant Group, which also owns the popular downtown bar the English Cellar Alehouse. Visitors are greeted by an impressive twenty-barrel brewing system adjacent to the spacious restaurant and complete with HDTVs, a large bar and a landscaped outdoor beer garden. Brutopia is the place to come enjoy a beer or watch the game with friends while enjoying some traditional-style beers, in-house hickory pit–smoked barbecue and five different barbecue sauces—most of which are made with beer.

Brutopia's beers are produced under the skilled and watchful eye of Sean Larkin (for more on Larkin, see the chapter on Revival Brewing). Acting as a consultant, Larkin and his team produce a wide range of beers, all made

Kristie Martin.

to pair with Brutopia's signature barbecue food, ranging from fried pickles to brisket. Year-round beers include Bliss Light Lager; Valhalla Amber Ale, with a medium malt body complemented by Northwest hops; Bonfire Brown, a beer that pairs up nicely with barbecue; Never Ender IPA; Dark Marvel Stout, with slight espresso notes and served on nitrogen; and Munk, a 10 percent Belgian-style Abbey ale. At any time of year, you'll also run into six additional seasonal offerings, such as a Belgian white, a hefeweizen or the Oktoberfest.

CHAPTER 5

COASTAL EXTREME
BREWING COMPANY

*The fishermen know that the sea is dangerous and the storm is terrible, but they
have never found these dangers sufficient reason for remaining ashore.*
—Vincent van Gogh

293 JT Connell Highway, Newport, 401-849-5232
www.newportstorm.com
Opened in 1999

Everyone who has gone away to college has done it. You're sitting in the
dining hall, talking with your friends about graduation plans. No one
really wants to work for anyone else, and someone will inevitably say, "Let's
start our own business!" That was the case with Brent Ryan, Derek Luke,
Mark Sinclair and Will Rafferty, students at New Hampshire's Colby-Sawyer
College. Three of the four friends had degrees in biochemistry. Mark had
a degree in physics, and Brent had an additional degree in mathematical
economics. After Derek taught Brent to homebrew on a kit that Derek had
re-gifted from his sister, brewing became a large part of the students' lives as
they continued to learn. When the "Want to open a brewery?" question was
asked, this group of pragmatic scientists saw it as a viable business idea, as
well as a way to combine their love of beer and fascination with the process.
"We knew we had to start the planning process immediately," Ryan recalled.
"It's not just about fun and games and making beer. It's about how we're
going to start a business and support ourselves."

When most people start a brewery, they select their hometown as the location. But for four college friends with no geographical common ground, they had to think outside the box. At the time, Rhode Island had no other packaging breweries. The founders knew that visitors vacationing to Newport loved to sample local products and that the craft beer market was alive in New England but hadn't yet trickled down to the Ocean State. They adopted Coastal Extreme as the company name but chose Newport Storm as their brand identity.

In April 1999, they moved into their 2,500 square feet in two garage bays in Middletown, just over the Newport line, and on July 2, their first beer, Hurricane Amber Ale, was released. For the first few years, and on a shoestring budget, the boys worked night and day. Brewing, marketing and distributing were a team effort as they worked to carve out a niche in a very static beer market. Although you don't see many on the market today, at the time, amber ales were one of the most popular beer styles in the country.

The late '90s were a tumultuous time for craft beer. Many breweries were slapping labels onto beers just to get them on the market quickly, overlooking quality control. The result was a lot of bad beer. "We wanted to do one thing, and we wanted to do it right," Ryan said. They worked for years brewing solely Hurricane Amber. It wasn't until 2006 that the brewery started production on its second year-round beer: Rhode Island Blueberry, a kölsch style made with local berries. In the meantime, the crew figured out that a great way to offer variety, while only asking retailers for one extra cooler spot, was to do a seasonal beer. They started out with an Oktoberfest, a porter, a Spring Irish Red and an India pale ale. Later on, the IPA summer offering was switched to a hefeweizen, and the India Point Ale, an IPA named after Providence's India Point Park, became the third year-round beer. The beer features Chinook hops grown at Ocean State Hop Farm alongside the lively and tropical New Zealand Motueka hop.

Ryan commented on how difficult it is to keep the attention of craft beer fans, who are often looking to quickly move on to the next new thing. "You need some people who are less inclined to just drink the big national brands and aren't necessarily looking to try something different every time they're at the store. It is very difficult as a brewery to keep the lights on if all you're relying on are the hardcore beer geeks." As a result, Newport Storm has prided itself on being a brewery directed toward Rhode Islanders and toward people looking to purchase a local product. This hasn't stopped them from being ahead of the game when it comes to brewing experimentation and variety. In 2000, their first Annual Release beer hit the market. Each

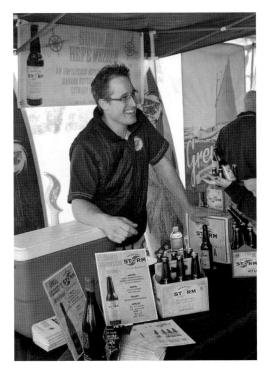

Newport Storm founder and brewmaster Derek Luke. *Coastal Extreme Brewing Co.*

beer in the series always falls outside the normal stylistic guidelines; couple that with a high ABV, a 750mL bottle and a limited quantity, and you have a beer that no one at the time had seen before. With their distinctive wax toppers, the Annual Release Series beers were designed to age and featured beers like '13, a coffee-infused dark ale; '12, brewed with agave and habanero peppers; and '11, a collaboration brew with each Rhode Island brewer, made with local hops, honey and a Rhode Island brewpub's Belgian yeast strain.

Newport Storm helped pioneer the one-off beer in New England with its Cyclone Series. Brewed and named sequentially like tropical storms, only a small batch of each unique beer was made. Starting with Alyssa, dubbed "an extreme brown ale," and ending with Zach, an imperial oatmeal stout, the series was a way for the brewery to engage its fans and beer geeks alike. "We want to give them things that are different, so they can be psyched up that they're supporting their local brewery but, at the same time, not having to drink the same beer over and over again. It's about saying thanks for supporting us," said Ryan.

In 2010, after years of growth, the brewery had a chance to build a new facility in Newport's North End, which increased its square footage to eight thousand, allowed it to build a visitors' center and gave it its first opportunity to upgrade its equipment since it first started. Mark and Will have since left New England for family reasons, but Derek stayed on as brewmaster, as well as in-house plumber, electrician and welder, among other things. Brent shouldered the responsibilities of president and master distiller of the company's latest venture: Thomas Tew Single Barrel Rum. Intern turned full-time brewer Jason Tsangarides and former brewery

Newport Storm founder and president Brent Ryan hosting an Annual Release vertical tasting in the visitors' center. *Coastal Extreme Brewing Co.*

landscaper turned brewer/ distiller Pete Lanouette rounded out the production team. In an environmentally friendly twist, by being both a brewery and a distillery, Newport Storm is able to reuse water during both productions, meaning less energy spent for heating and cooling.

Although the Cyclone Series has reached its end, Derek and his team are working constantly creating new and exciting offerings. Brewing on a thirty-barrel system, as opposed to their old ten-barrel system, allows more time spent on development and test batches, along with a focus on their barrel-aging program, which brought Rhode Islanders Angel's Envy in 2013—named after a twist on the distilling term "angel's share," referring to the evaporated portion of an aging spirit that floats up "toward the angels." The angels are denied, however, once beer is put into the barrel to soak up the oak flavors. In 2014, the brewery released InfRIngement, an imperial stout aged in freshly dumped Thomas Tew Rum barrels, as well as Mass HysteRIa, a double IPA also aged in oak barrels. These beers are two of the brewery's smallest batches yet and are the culmination of years of exploration into the barrel-aging process.

The brewery is seeing yet another expansion in 2014, adding an additional 25 percent to the facility and even stretching its distribution into Pennsylvania. Over the years, Newport Storm has established itself as the beer of Aquidneck Island, with events such as its annual luau and the infamous Fridays@Six, which has been providing locals with beer samples at no cost every Friday since the brewery's earliest days.

THE BEER

Hurricane Amber Ale, the brewery's first beer, continues to be its most popular. Hurricane Amber is a delicately balanced amber ale. Spicy Tettenang hops complement the bitterness atop a light malt sweetness. Rhode Island Blueberry is a kölsch-style beer made with fresh locally grown blueberries, fermented at colder temperatures and combined with an American ale yeast strain that eliminates any fruity esters, allowing the blueberry flavor to shine. India Point Ale is a 6.5 percent IPA brewed with five different hops added at seven different times, resulting in a complex hop flavor alongside a substantial Munich malt backbone. Other offerings include the Storms of the Season (Winter Porter, Spring Irish Red, Oktoberfest, Summer Hefeweizen and R.I.P. Rhode Island Pumpkin), Cyclone Series (retired), the Annual Release Series, a pilsner (summer variety pack only) and the Barrel Aging Program. The most recent additions to the Newport Storm lineup, and the brewery's first four-pack release, are Wham! Bam! Van Damme, a Belgian pale ale, based on the recipe used for Cyclone Sabrina, as well as a smoked porter, which is exclusive to its 12 Sheets to the Wind seasonal mixed pack.

CHAPTER 6

REVIVAL BREWING COMPANY

In Vino Veritas in Cervesio Felicitas. ("In wine there is truth, in beer there is joy.")

www.revivalbrewing.com
Opened in 2011

When Revival first came on the scene in 2011, it brewed its draft accounts out of Trinity Brewhouse, where Revival owner Sean Larkin worked, and bottled its beer at Cottrell Brewing in Pawcatuck, Connecticut. As Sean moved on from Trinity, so did Revival, making its new home at Cranston's Brutopia Brewery and Kitchen, where Sean now works as brewmaster, beer mentor and consultant.

Sean became interested in beer while working at Trinity part time in the kitchen. While there, the previous head brewer, Kurt Musselman, needed an assistant and offered Sean the job. While working there, Sean discovered the deep relationship between food and beer and ended up taking over in August 1996.

Eventually, he started Revival in 2011 with his partners and friends, MIT grad and avid homebrewer Owen Johnson and creative director/RISD alumni Jeff Grantz. "I'd been working in designing beers for the guys at Narragansett, and then around 2008, I decided that I wanted to make sure I secured my own destiny, so to speak," Sean explained. They slowly began raising funds and brewing beer in small batches. The beers for Revival were different than the recipes he was designing for Narragansett and Trinity. Sean wasn't looking to

compete with their portfolios of beer and instead wanted to offer styles that he described as boutique and higher-end. Their mission was to be as distinctive as possible and fill in the style gaps in the offerings of Rhode Island beers. Sales were modest in the beginning, but as Revival's reputation grew, more and more calls came in from people demanding their unique beer. Today, Revival is available throughout Rhode Island and into Massachusetts and Connecticut.

Sean, who grew up in Rhode Island and feels a connection to the state, wants to keep the brewery there, even though other states may offer cheaper taxes. The brewery works with the local community and local businesses to develop beers that are distinctly Rhode Island. "I at least want to take a chance and start things here. I love Providence as a city. It's a vibrant, artistic, creative city and that fuels a lot of the recipes behind Revival," said Sean.

THE BEER

Revival's saison is an unfiltered, dry-hopped Belgo-American beer, combining aspects of the Pacific Northwest with Belgian malts and yeasts. The Imperial Oktoberfest Lager is an Oktoberfest with attitude; sweet and malty, with leafy hops alongside some of that nice märzen breadiness, this is a great autumn beer. Larkin's Dry Irish Stout is smooth and sessionable, with flavors of milk chocolate and black coffee, while Juliet 484 Imperial Stout, named after the Russian submarine that served as a Providence waterfront museum until it sunk in 2007, is creamy and complex, with a touch of smoke.

Mercy Brown Imperial Ale takes its name from a sixteen-year-old Exeter resident who died of consumption in

Revival's Double Black pairs up Chinook and Sorachi Ace hops with roasted malts to create a knockout of a beer. *Ashleigh Bennett.*

1892. After other members of her family were stricken with the disease, it was assumed that Mercy must have been a vampire, causing the sickness. Revival appeases her spirit with this malty brew, full of dried plum and caramel tones. The What Cheer? Pilsner is a light and refreshing Bohemian-style pilsner, and Rocky Point Red Ale balances a honey malt mix with Citra and El Dorado hops.

Recently added to the Revival bottled list are Zeppelin, a traditional German hefeweizen full of banana and clove-like flavors, and Burnsider Pale Ale, a 5.5 percent American pale ale with a nice balance of citrus and caramelized malt notes.

White Electric Coffee Stout, a limited-release beer made with New Harvest coffee beans, swept through the city in the fall of 2014, along with Fanny IPA, named after the elephant that lived in Pawtucket's Slater Park Zoo until its closure in 1993. Fanny was then sent to the Black Beauty Ranch in Texas, where she spent the next ten years living among other elephants, developing a unique friendship with one elephant named Conga. Larkin plans to release Conga Imperial IPA shortly after Fanny, envisioning Fanny and Conga at side-by-side taps.

CHAPTER 7

GREY SAIL BREWING
OF RHODE ISLAND

So throw off the bowlines. Sail away from the safe harbor.
Catch the trade winds in your sails.
–Mark Twain

63 Canal Street, Westerly, 401-315-2533
www.greysailbrewing.com
Opened in 2011

Rhode Island has more coastline per square mile than any other state. The Rhode Island Tourism Division boasts more than four hundred miles of coastline in the tiny state, with almost any location falling within thirty minutes of the sea. Rhode Island's connection to the ocean runs deep, and stemming from this nautical connection is Grey Sail Brewing of Rhode Island, the state's second production brewery. Tucked away at the threshold of the Connecticut border lies Grey Sail, founded by Alan and Jen Brinton.

Alan and Jen run an impressive operation, especially when one factors in their four kids and full-time jobs. Jen works as a wedding planner and Alan as a chemical engineer—on top of running a brewery. They moved to Rhode Island in 2000 from New Jersey, and throughout the years, their devotion to beer has flourished. Alan's chemical engineering background made the brewing process second nature to him. He always had plans to open a microbrewery or a brewpub, but after meeting Jen, having kids and

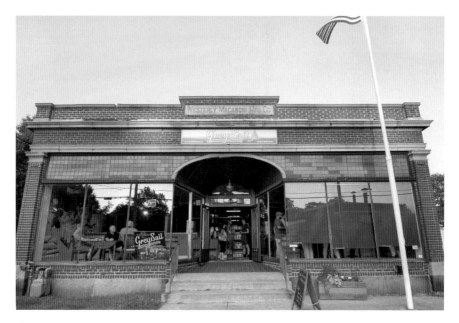

Grains come full circle in Westerly—what is now Grey Sail Brewing used to be the Westerly Macaroni Manufacturing Company. *Ashleigh Bennett.*

moving, plans were derailed for a bit. On their tenth wedding anniversary, Jen said to Alan, "Let's go ahead and do it."

In 2011, the couple started putting their plan into action, and when they saw the Macaroni Building in Westerly for sale, they realized they had found the perfect opportunity. That isn't to say they didn't have a lot of work to do. The building, a former Napa Auto Parts, needed extensive internal reconstruction to transform it into a brewery. After seven months and lots of elbow grease, the building was starting to look more like a brewery. With the help of friends licensed in trades like welding and pipefitting, the building started to come together.

That's not to say it was easy. Balancing the brewery, work and family has been a feat in itself, and Jen said that it was a lot of work just to keep their lives normal. "The hope is that the brewery grows and sustains and is something that is there for our children to take over," she said. The brewery was originally nicknamed Grace Ale, after their daughter. This shifted into their official name of Grey Sail because of their coastal ties, as well as how when you look out toward the horizon on these cold New England beaches, the sailboats have a tinge of gray to them.

The chimney that gave name to Leaning Chimney Smoked Porter—inconveniently placed but part of the building's history that the owners wanted to preserve. *Kristie Martin.*

They had a name and a location, but a successful brewery needs a good brew crew. Jen and Alan hired Daniel Rivera as the "Guy for All Things Grey Sail" to help out, along with Josh Letourneau as head brewer. On November 11, 2011, they brewed their first batch.

Grey Sail was a success, and after a year of operation, Jen and Alan took on Michelle Kirms as assistant brewer. Their second year saw 85 percent growth, and they continue to hold strong in their third year. Grey Sail sells about 2,300 barrels annually and has the capacity to make up to 5,000. The goal is to reach 10,000 barrels and stretch its distribution. Currently, its beers can be found in Rhode Island, Connecticut and Massachusetts.

Grey Sail has expanded to include an automated canning line, automated keg filler, two new fermenters and a new brite tank. "Before the automated canning line, it was a very manual process. Very tedious—two cans at a time—so we are very excited to have the automated line," said Jen. Alan was ahead of the curve with his decision to can craft beer. Alan felt that cans preserved the quality, as they are better suited to keep out light and oxygen. The decision to can was also based on their coastal location. "Bottles are not accessible for boats and various outings like hiking, boating, golfing— lots of things that New England is known for. Cans are just much more suitable for that and are much more environmental," Jen explained.

The canning falls in line with Jen's larger philosophy toward beer: "We kind of do our own thing and don't worry too much about what everyone else is doing. That's just the way we've always operated. But it's great. It helps to widen the beer culture and make more people aware. We still have a long way to go, but the beer culture in Rhode Island is growing."

THE BEER

Grey Sail has a diverse range of beers, developed by Alan and Josh, offering libations for any palate. It offers a different style every month as part of its Chalkboard Series and also does local collaborations. Based on the Rhode Island tradition of coffee milk, Grey Sail paired up its Stargazer Imperial Stout with organic coffee from Dave's, a local coffee purveyor and roaster, to create the Dave's Coffee Stout. It also does an annual anniversary beer, various one-time releases and something for American Craft Beer Week in May.

Flagship Ale is a golden-colored cream ale at 4.9 percent ABV, brewed similar to European lagers, with balanced malts and hops. This is a great gateway to craft beer—good for the beer drinker who wants to be a craft beer drinker but isn't ready for the high-hop profile of many IPAs or the high alcohol content. Flying Jenny Extra Pale Ale is a 6 percent ABV beer named after the sail depicted on the can, the Flying Genoa. When it's in full wind, it's called the "flying Genny," and since their daughter's name is Jennifer, they changed the *G* to a *J* in this unfiltered, extra pale ale with a citrusy and floral hop flavor and aroma. Leaning Chimney Smoked Porter is a 6 percent ABV robust porter brewed using peat-smoked malt, with the addition of American hops to create a piney flavor with a smooth finish. Hazy Day Belgian Wit is a 4 percent ABV beer representative of the white beers made in the Wallonia region of Belgium and is spicy and unfiltered. Autumn Winds Fest Beer is a 5.8 percent Oktoberfest-style ale brewed with five types of German malts, creating a bready aroma with a deep red color. This is complemented with Hallertau and Saaz hops. The brewery launched its third year-round beer in the fall of 2014: Captain's Daughter, a double IPA (8.5 percent) packed with Mosaic hops. The most recent news from Grey Sail is the Little Swell Series, which kicked off with Dark Star, a Belgian imperial stout aged in bourbon barrels, and Flotsam and Brettsam, an IPA aged in wine barrels with Brettanomyces.

CHAPTER 8

BUCKET BREWERY

For pleasure has no relish unless we share it.
—Virginia Woolf

545 Pawtucket Avenue, Pawtucket, 401-305-0597
www.bucketbrewery.com
Opened in 2012

Pawtucket is quickly becoming the brewery hot spot of Rhode Island, which is interesting given its size—only eight square miles—and it's far-from-kind nickname. Mayor Don Grebian ran on a platform that included bringing in water-intensive industries, such as breweries, after the city saw a $42 million renovation to its water treatment plant. Bucket Brewery, with its tongue-in-cheek name, is part of the Pawtucket brewing renaissance, bringing life back into the old mill city and making it a destination in itself.

"We pretty much have the same story as Foolproof," joked co-owner Nate Broomfield. "I was getting married, and we wanted to have a lot of homemade beer, so Erik [Bucket co-owner Erik Aslaksen] came over. We brewed a ton, and all of the beers just came out spectacular." They started tossing around the idea of starting their own brewery and soon realized that with their group of friends, everyone had something he could provide to make the project happen. It was like Captain Planet but with beer: "By our powers combined!" TJ O'Connor provided some larger brewing equipment; Drew Powers had the brewing prowess,

The Bucket brewhouse. *Kristie Martin.*

having won a local brewing competition; and Ron Klinger brought the business and money skills.

The group found its first location in the Lorraine Mills, now home to Crooked Current Brewery, and sent out its first keg of beer in November 2012. "We mostly started off brewing what we had been making as homebrews," said Nate. "Those had already gone through a lot of revisions. Our pale ale, the maple stout—we honed our skills trying to perfect those." It soon became clear that five guys working in a 375-square-foot room was not going to cut it, and in June 2013, the pilot brewery was closed and construction began on a larger production brewery, located in the mill on Pawtucket Avenue. This new location allowed Bucket to expand tenfold—ten times the brewing capacity and ten times the floor space, giving them 3,400 square feet and a ten-barrel brewhouse.

With the new location, tours and tastings are now possible. Bucket has taken full advantage of turning the brewery into a spot for people looking to not only learn more about the brewing process but also to enjoy a night out with friends. On the third Friday of every month, the brewery hosts Sound Check, an event featuring live music, local food, raffles and, of course, Bucket beer. "We're trying to make this a place where people want to spend their time. We know we're lucky to have this, so we want to share," said Nate.

Community outreach is a large part of what Bucket Brewery wants to accomplish in the Pawtucket area. From April through June, it hosts a running club, and it also plans to launch an introductory homebrewing class where attendees will be able to learn the process and then go home with a homebrew kit alongside a clone recipe of a Bucket beer. "Bringing people right into the process is fun," said Nate. This attitude of inclusivity is carried over to their tours and tastings. You never know what you might try when you go to a Bucket tour—sometimes a taste straight out of the fermenter or a sample of one of its many test batches.

You'll always find three to four year-round Bucket beers available, along with an assortment of seasonals and brewery experiments. The summer of 2014 saw the Cranberry Orange Farmhouse, a beer that was originally brewed for a beer dinner but was kept on due to popular demand. "We're going to come up with a lot of different recipes to have in our back pocket that we can throw out," said Nate. One such recipe was the result of accidentally adding too many grains while brewing the pale ale—an additional eighteen pounds. Not wanting to waste the beer, Erik raced to the store, came back with unsweetened chocolate and oranges and turned what would have been destined for the drain into a chocolate-orange stout.

Currently, Bucket is distributed in Rhode Island only, with sixty-four-ounce growlers available at the brewery and thirty-two-ounce "growlettes" distributed to stores. Bottling the growlers is a very manual process, allowing the brewery to ship out only about forty to fifty cases per week. Plans are in the works for an expansion that would include a bottling line, giving Bucket the chance to branch into six-packs and opening up possibilities for additional growth. Said Nate, "Until recently, a lot of people didn't know we existed, but in the past couple months, it's really started to take off. It's a great feeling."

The Beer

These are some of the Bucket offerings that you're likely to see around town at your favorite bar or liquor store. The Pawtucket Pail Ale is brewed with malts designed to deliver a toasty, nutty flavor and hops geared more toward floral aromatics and tangerine notes instead of bitterness.

Rhode Scholar, a kölsch style, is light with a subtle citrus—a great summer beer. During their homebrewing days, the Bucket brewers threw in a cup of

maple syrup in an attempt to revive a stout that they thought had stopped fermenting. The result was 13th Original Maple Stout, a beer that has grown and developed with the brewery since the beginning. Rounding out the lineup is the Park Loop Porter, brewed with grains and hops that keep with the porter's British ancestry, delivering coffee and almond notes.

The brewery took a big step in early November, releasing its first IPA: 9 Men's Misery, which takes its name from the country's oldest veterans memorial, located in Cumberland. After a battle between English colonists and the Narragansett tribe, ten colonists were taken prisoner—nine were killed, and the tenth was freed to tell the tale, or so they say. To further represent the battle, the beer features British malts alongside flaked maize, representing the Narragansetts. This was shortly followed up by Merci Buckets, a French-style saison brewed with lavender, coriander and linden flower. In true saison fashion, the beer is designed to be light and drinkable and pair well with food.

CHAPTER 9

RAVENOUS BREWING COMPANY

Tell me what thy lordly name is on the Night's Plutonian shore!
Quoth the Raven, "Nevermore."
–Edgar Allan Poe

840 Cumberland Hill Road, Woonsocket
www.ravenousbrew.com
Opened in 2012

In a sea of nautical beers, nanobrewery Ravenous Brewing offers a connection to another, darker New England facet: Boston-born writer Edgar Allan Poe. Founded by Dorian Rave in 2011, Ravenous was launched at Autumnfest in Woonsocket in 2012 and is the city's first brewery. Dorian started the brewery after being a homebrewer for a few years. As he evolved from extract brewing to all-grain, he began to build his own recipes and started to consider the craft of brewing as a career. Once Dorian realized that it was something he wasn't going to tire of, he began to develop the brewery. "We took the leap, decided to go for it. We were all in and going to make it happen," he said.

Dorian decided on the name Ravenous by combining a bleak, wintery New England theme with his last name, Rave. "It captures the essence of Poe, New England—in the future, those darker elements will be captured in the label," Dorian said.

Dorian works as the owner, with Chris Combs as his assistant brewer. At the time of publication, all of their work is done without financial

compensation. These guys are in it for the beer. Chris has been a valuable asset to the company. Some weeks he is there more often than Dorian, brewing voluntarily. Dorian and Chris met about a year after the opening of Ravenous at a local beer festival. Chris had previously brewed at Trinity Brewhouse and told Dorian to call him if he ever needed help. One day, Dorian took him up on the offer, and he recalled that when Chris first got there, he knew just what to do, and the two of them were always thinking one step ahead of each other. In May 2014, Dorian broke his femur at the hip and said that if it hadn't been for Chris stepping up to the plate, he would have had to shut the place down. "He took the bull by the horns, not getting paid and volunteering through the kindness of his heart," said Dorian.

Any money they earn goes back into the development of the brewery, be it equipment or paying the bills. "It's a passion," explained Dorian. "We do it for the love of craft beer and being a Rhode Island brewery and pushing forward. One day, I hope that changes and we can employ ten, twenty, thirty

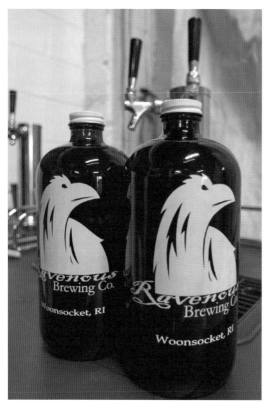

people, but for right now, we just do it as a labor of love." On top of this, Chris and Dorian, a police officer, work full time, and both have families. "Every week is a juggling act, but we make it happen," he said.

Ravenous offers two year-round beers: its Blackstone Pale Ale and its Coffee Milk Stout. The rest of the year is peppered with other offerings. Dorian will ask Chris what he wants to brew, and they go from there. "It's cool because although we still enjoy brewing our Coffee Milk Stout and pale

Ashleigh Bennett.

ale every day, it kind of becomes a routine, and trying new recipes takes us back to our original roots, where we get to enjoy building new recipes," noted Dorian.

They brew one-hundred-gallon batches, which can make it tough to keep up with the draft lines they distribute to, as well as bottling beer for their brewery. "It's a challenge, but we overcome it," Dorian said. "Week in and week out, we miraculously just happen to have it work out. It's exciting when you open up, and your biggest fears are, 'What if I don't sell my beer?' But the problem has been the opposite. We almost can't keep up with beer demand." Dorian said that this is a better problem to have, but it's still a challenge as he strives to fill that demand and keep his beer at the high quality that drinkers have come to love.

Dorian hopes that Ravenous will grow a little more, but he never wants it to become a huge brewery. He wants to be at the point where he can comfortably make the beer that they need to keep customers and demand happy, while still hanging on to their informal, neighborhood feel. They pride themselves on that aspect of the brewery and never want to lose that connection with the community.

THE BEER

By definition, they only do one seasonal beer, the October Black Harvest, a sweet potato stout. Other limited releases include red ales, barrel-aged beers and sours. The brewery's beers are available on draft at select bars or available at the brewery in howlers/half growlers.

Year-round, you will find the Coffee Milk Stout, based on one of Dorian's homebrew recipes that became a favorite among friends and family. It started out as a coffee stout until he added some lactose, which seems a perfect fit, as coffee milk is such a Rhode Island staple. The result is a rich and creamy beer with a delicate balance of roasted barley and local coffee. Blackstone Pale Ale is a traditional American pale ale, coming in at 6 percent and with a spicy/floral hop flavor.

CHAPTER 10

FOOLPROOF BREWING COMPANY

Nyuk Nyuk Nyuk!
—Curly, The Three Stooges

241 Grotto Avenue #1, Pawtucket, 401-721-5970
www.foolproofbrewing.com
Opened in 2012

Beer and good times—the two go back for centuries and are often hand in hand. This is depicted in songs, movies and paintings spanning the ages. And nobody understands that relationship more than Foolproof Brewery founder Nick Garrison. Foolproof is tucked away in a Pawtucket industrial park, producing beer that is now sold in Rhode Island, Massachusetts, Vermont, Connecticut, New Hampshire and Texas—an impressive scope given the size and age of the brewery.

Nick founded Foolproof Brewery in 2012. Like most brewers, he got his start in homebrewing, but opening a brewery wasn't in his initial life plan. Originally from Massachusetts, he moved to Rhode Island after graduating from Tufts to work in the aerospace industry doing marketing work. His homebrewing hobby soon spiraled into an obsession. "I fell in love," said Nick. "Every waking hour, I was reading about beer, drinking beer. It was just beer, beer, beer all of the time. It was different than any other hobby I've had before."

Nick went out on a limb and brewed seven different kinds of beer for his wedding—an IPA, a pale ale, a nut brown, a stout and a porter, to name a

few. Throughout the wedding, people were coming up to him and asking him where the beer was from. When they found out that he made it, they joked that he should quit his job and start a brewery. The seed was planted. On their honeymoon in Quebec, he and his wife were enjoying a nice beer in the sun at a brewpub. "It was just a great moment, and my wife, Sarah, said, 'Hey, wouldn't it be cool to own a place like this?'" At that exact moment, Nick realized that he had to start a brewery. Thoughts were jotted down, locations were scouted and the networking began.

With the support of his friends, family and colleagues, Nick jumped into learning everything he could about the business end of breweries. It took a year and a half to get a team in place and secure the equipment and financing. The City of Pawtucket was welcoming as well. After an initial offer was turned down in Providence, Herb Weiss, from the City of Pawtucket, pushed for them to open up in the city. "I actually had a great conversation with the mayor once where I told him, 'Behind every great city, there should be a great brewery, and we want to be that brewery for Pawtucket.'" The city agreed.

Now that a location was secured and things were underway, Nick had to get together a crew. He met brewmaster Damase Olsson on BeerAdvocate, and

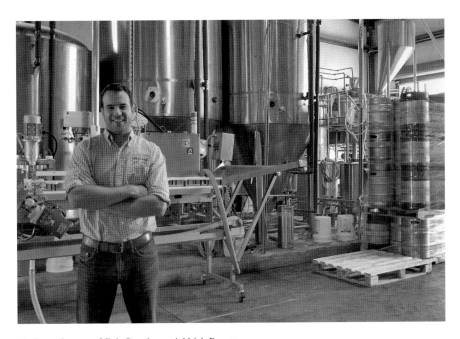

Foolproof owner Nick Garrison. *Ashleigh Bennett.*

Designated areas in the Foolproof tasting room. *Kristie Martin.*

the two hit it off. Damase also homebrewed as a hobby and eventually left his career as a chemist to attend brewing school, a fate all too fitting given that he is the forty-sixth-generation grandson of St. Arnold of Metz, the patron saint of brewers. He volunteered at Nashoba Valley Winery and Brewery and worked at Pennichuck Brewery in Milford, New Hampshire. Nick was to run the front of the business, while Damase ran the back. Nick left his job in summer 2012, and he and Damase would spend days in the air-condition-less industrial park bay installing flooring, painting and hauling in equipment.

The next step was to choose a name. Nick decided on the Foolproof name after finding that their original name, High Jinx, was the name of a trademarked wine. "The jester is all about having fun, having a good time and maybe being a little mischievous. And that's why people drink beer—because it's fun. We felt like it really embodied the spirit of beer drinking but also the culture we wanted to create," Nick explained. This is manifested in all aspects of the company, from its branding to the brewery itself. Its brew tanks and fermenters are named after great comedians—Curly, Larry, Moe and Groucho, to name a few— and a whimsical jester adorns its cans and is painted on the taproom wall.

By the close of December 2012, Foolproof was set to open. It brewed its first batch on December 7 and launched the brand in January 2013. Rhode Islanders embraced the brewery, and in March 2013, it added three new fermenters, which allowed it to expand into Massachusetts. By the fall of 2013, it was able to expand again into Connecticut. The company also grew, adding Bill Dillon, packaging operator, who staffs brewery tours and tastings; brewer and sales manager Stefano DeAngelis; and brewer Steve Sharp to the team.

The Beer

Foolproof treats beer drinking as an experience, not just sitting in a bar and jotting down notes on aroma and mouthfeel. It pairs beers up with sacred, everyday experiences. "Just like you might pair wine with food or beer with food, we pair beer with life. Who hasn't come inside on a rainy day and wanted a nice dark beer? Or been on a beach and want something light and refreshing or want a beer after a long workday?" asked Nick. With this philosophy in mind, Foolproof began to brew beers to go with different experiences. Here is its current lineup.

Barstool is its lightest beer. This beer beat out twenty other golden ales and took home a gold medal at the Great International Beer Festival. This beer is jokingly called a gateway beer. It's a beer for people who don't drink a ton of craft and prefer a lighter beer but still want something local and flavorful. Barstool's a perfect fit. Pair it with going out to a pub with your friends and sitting on a barstool.

Backyahd, an IPA, is its flagship beer and top seller, accounting for about 42 percent of sales. It's an approachable, balanced IPA. "It doesn't take the enamel off your teeth. We're not trying to win the hops arms race with this beer," said Nick. It's a blend of an English and West Coast IPA (with Rhode Island falling right in the middle). Pair this beer with grilling or simply hanging out in your "backyahd."

Raincloud is a canned porter that won a silver medal at the Great International Beerfest. Coming in at 6.5 percent ABV, this is its "crappy day" beer, perfect for when it's raining or snowing. Pair with bad weather, Netflix and pajamas.

La Ferme Urbaine (LFU) is a canned farmhouse ale, one of its more popular spring and summer beers. Full of citrus and spice, it started out as a specialty beer in twenty-two-ounce bottles, but it was so well received that it became a staple, year-round offering.

King of the Yahd is, like LFU, a double IPA that also started as a specialty offering. Production of this beer is limited by the hops available. In the past, it's been made with Citra and Amarillo hops. Depending on what hops Foolproof can get, it tweaks the recipe and relaunches the beer annually.

Revery is a bit of a cult classic. This Russian imperial stout is released in a twenty-two-ounce bottle and is its strongest beer, coming in around 10 percent.

Augtoberfest is for when Oktoberfest falls in August, more or less. This fest beer is based on Oktoberfest recipes and uses all Munich malts, while the hops take the backseat. It's a fall beer, offering drinkers a break from the pumpkin madness.

CHAPTER 11

NARRAGANSETT BREWING COMPANY

"It's alive!"
–Dr. Victor Frankenstein

www.narragansettbeer.com
Opened in 2005

Narragansett Brewery is the phoenix of the Rhode Island beer world. Although the brewery was closed in 1983 and any last vestiges of it put to the wrecking ball, it rose again. The brand was still around prior to the resurrection, but it was a shell of its former self. At most, Narragansett sold six thousand cases per year, mainly to dive bars, old-timers who never stopped drinking it and a few Providence locations like the Decatur Lounge (now The Avery).

In 2005, businessman Mark Hellendrung, from East Providence, resurrected the Rhode Island staple. Mark worked at Nantucket Nectars for ten years and Magic Hat for two years.

While working in the beverage industry, he noticed that regional heritage brands were still alive and well around the country—breweries such as Yuengling in the Mid-Atlantic and Lone Star in Texas. "My original thought was that New England is so parochial and provincial, if anyone should have their old beer back, it should be New England. It's not like Florida, where it's all strip malls and nobody gives a shit about the history," explained Mark.

Since growing up in Rhode Island, Mark had his own history with Narragansett. It was the token beer at college parties when he went to Brown and sold at the liquor store where he worked and at the local bars. He recognized the local pride in the beer and understood that everyone has a story connecting them to 'Gansett. "There's Rhody pride, and there's also the whole summer magic of, 'Ohhh I remember sitting at Misquamicut and going over to the Andrea Hotel and cranking 'Gansetts on a Saturday!'" he explained.

Mark ended up buying the rights to Narragansett from Pabst in 2004 to re-launch the brand in 2005, putting it back on the market. He had some detective work to do before launch day, including reuniting with Bill Anderson, brewmaster at Narragansett from 1967 to 1975. The pair reformulated the original recipe to make it appeal to modern beer consumers by upping the hops and alcohol level. After this, they began working with High Falls, now North American Breweries, to bring back 'Gansett. Their offerings now

include styles that may seem brand new but are actually steeped in brewing history. The Narragansett Bock dates back to 1933 and the porter to 1919. In reviving the brand, Hellendrung and his team are attempting to fill the void that big breweries like Anheuser-Busch created in the 1970s when they put the regional brewers out of business.

To reach its new audience, the brand had to find a balance of the classic design alongside a contemporary one. Mark partnered with an ad agency that took the elements of Narragansett past and used those to move forward. "You look at our lager twelve-packs,

In 2012, 'Gansett produced a limited-edition 1975 retro can so drinkers could take a move from *Jaws* and "crush it like Quint." *Ashleigh Bennett.*

and you can point to something from the '70s, something from the 1900s, something from the '20s, from the '50s. And then the ad agency are the ones who put it in a blender, and it came out just beautiful," Mark explained.

Currently, there is talk about the brewery returning to Rhode Island; however, as of the time of publication, the beer is contract-brewed, a decision Mark doesn't regret. The type of brewery required to handle their production requirements would be a $10 million to $15 million investment, and Mark felt that the quality of the beer coming out of North American Breweries (N.A.B.) was just as good, if not better, than anybody else could make. They keep it local as much as they can, though, and brew and fill their bombers over at Buzzards Bay Brewing in Westport, Massachusetts.

The Beer

The new Narragansett started out offering only the light and lager, but it has brought back some of its older recipes as well, such as the bock and fest. Its gradual progression into craft has introduced beers such as its Private Stock Series, as well as beers created through partnerships with other Rhode Island beverage producers, such as the Autocrat Coffee Milk Stout and the Del's Shandy. Mark feels that these collaborations give them a gravitas in the community, helping to set them apart. They seemed to have struck a chord with Rhode Islanders, as both beers can't seem to stay on the shelves. At the time of publication, 'Gansett announced its latest Rhode Island–inspired brew, a collaboration with Revival Brewing: Lovecraft Honey Ale, celebrating Providence's own father of modern horror, H.P. Lovecraft. The beer was released on January 19, 2015, the birthday of Edgar Allan Poe.

Narragansett's recipes are created and perfected by Sean Larkin. "We'll come up with an idea, like what flavor category, and then we just turn it over to his brilliance. He's one of the best, and we get in the way if we get too close to it. Everything he makes is great," said Mark.

Narragansett Lager is a 5 percent classic American lager with a bit more flavor than your typical premium lager. Narragansett Light is a 3.8 percent total lawnmower beer. Fun fact: Narragansett actually brewed one of the first light beers in the United States back in the '60s, called "96," named for its number of calories. Bohemian Pils also joins the lager and the light in the year-round lineup. Each season brings about a different 'Gansett seasonal

brew—Summer Ale, fest, porter and bock. The Private Stock Series features twenty-two-ounce limited-edition offerings such as the Town Beach Imperial IPA, a well-balanced, citrusy beer, and the Imperial Bohemian Pilsner, 'Gansett's first unfiltered beer. Other beers in the series include the Black Steam, a dark California common, and an imperial Russian stout.

CHAPTER 12

PROCLAMATION ALE COMPANY

Boldness be my friend.
—William Shakespeare

141 Fairgrounds Road, West Kingston, 401-787-6450
www.proclamationaleco.com
Opened in 2014

Rhode Island's latest success story is Dave Witham and his West Kingston brewery, Proclamation Ale. Having not even been open a full year, Witham has already found himself with product demand far exceeding his brewing capacity. A beer called Tendril is at the forefront. Labeled as "1½ times an IPA," Tendril takes you through a whirlwind of resinous hop flavors, from fruity to piney, all held up by an English crystal malt body that still lets the greenness shine though. "Right now, the market is flooded with gateway beers. Only recently are some people starting to push for different things," Witham noted. Right off the bat, Proclamation has gone big. With a bold IPA, alongside an expanding sour and barrel-aged program, these beers are doing exactly what the brewery name suggests—making a statement.

A Rhode Island native, Dave spent the past ten years working as a music teacher after attending sound engineering school in Arizona. After he and his wife decided that upon the birth of their first child, Dave would play the role of stay-at-home dad, they realized that it would be the perfect time to slowly grow a business. By the time their daughter was ready for school,

they could be operating something sustainable. "Plus, I don't want to try and reenter the workforce when I'm forty-four years old. That thought terrified me," Witham joked. With that, the homebrewer/musician became parent/ brewery owner.

The brewery is inauspiciously located in a large warehouse, nestled next to a lumberyard. "At the time I signed the lease, the growler law hadn't passed yet. I wasn't concerned with the location because there was no reason to have any foot traffic," said Witham. It wasn't until 2013 that Rhode Island breweries were allowed to sell samples of no more than seventy-two ounces, in conjunction with a tour and/or tasting. People remain unfazed regarding the location. The brewery sees up to sixty to seventy visitors in the span of a Saturday afternoon. Witham came across the location through friend Mike Reppucci, owner of Sons of Liberty Spirits, a distillery located less than five miles away. What the building may lack in accessibility, it makes up for in its expansion capability. The ceilings are high, allowing for larger tanks, and it has the possibility of expanding in many directions.

Navigating the brewery permit process went relatively smoothly for Witham, although he anecdotally recalled, "I was scared shitless of the fire marshals. They can tell you one thing, and then you have to redo everything. They wanted me to have an emergency exit in the back, and I was like, 'The train tracks are right there. You're gonna have people leaving with a buzz and getting drilled by a train.'" After jumping through the bureaucratic hoops, the first batch of Tendril was brewed in early January, with the first kegs heading into distribution in early February 2014.

Proclamation brews 3.5-gallon batches, netting a little over 100 gallons of beer. "I would have loved to open a fifteen-barrel system, but I wanted to use the money me and my family had. That way, there wasn't pressure to bring money in. No investors on my back," Dave said. From the get-go, Witham has engaged craft beer drinkers by producing a big IPA right off the bat, along with other niche styles that hold the same growing demand. It's a fine line that brewers walk between producing what sells and what you actually enjoy. "I always want to be on the line of what's commercially viable and what's creatively stimulating," said Dave. "You want to do something that's interesting enough to make you feel fulfilled but still good enough that people are gonna want to drink it."

The crew is staffed entirely by volunteers, and Dave appreciates the help. "Brewing itself is so romanticized. You're just mopping the whole time. And getting sweaty. It was so much more relaxing when I was a homebrewer," said Dave, laughing. Proclamation's commitment to beer is apparent, and

Barrel room at Proclamation Ale Co. *Kristie Martin.*

Dave is excited, watching as other local breweries venture into new and experimental brewing territory. "Changes are definitely happening," he said.

Demand from the local market has been so strong during the brewery's first year that big changes are already in the works. In the fall of 2014,

Proclamation announced news of an expansion to happen mid-January 2015 and slowly continue into the spring. The production of Tendril will be moved to a contract-brewing facility, ramping up production from the current three to four barrels to a whopping sixty-barrel batch. By March, the brewery looks to release Tendril cans. "I'm not gonna lie—the can designs for Tendril look pretty f-ing badass," said Dave. He continued: "The money from the canning and contracting will end up coming back to the brewery, and then we can start upgrading the facilities."

The Beer

Along with Tendril, Proclamation also produces Zzzlumber, a "Dutch imperial stout," coming in around 10 percent, with a surprising drinkability coupled with a richness. Plattelander is a traditional-style saison. Keraterra uses 100 percent Brettanomyces Bruxellensis Trois yeast, fermented in pinot barrels and dry-hopped with Citra and Amarillo.

Come spring 2015, Proclamation hopes to triple the size of its fermenters and add many more oak barrels for its aging and souring programs. By upping the capacity and taking Tendril off-site, more time and room will be available for the fun stuff. Look for more one-offs and seasonal beers, as well as an increase in bottling, so specialty beers can be sent out to stores rather than served tasting room–only—beers like Son of Sim, the Simcoe-heavy IPA; Plattelander Rood, a funky red saison aged in Pinot Noir barrels; and Derivative, a juicy pale ale full of Galaxy, Amarillo and Citra hops.

CHAPTER 13

WHALER'S BREWING COMPANY

Call me Ishmael.
–Herman Melville

1070 Kingstown Road, Wakefield, 401-284-7785
www.whalersbrewing.com
Opened in 2014

Arriving at the old Palisades Mill in Wakefield reminds you of a time when mills were the cultural and industrial centers of Rhode Island communities. Entire town infrastructures were built around the mill. They were centers of commerce and of life. Down a set of stone steps is the sound of people shooting pool. You enter Whaler's Brewing and see people laughing and sharing a beer in a building that had been silently tucked away and used as storage for years. Rhode Island's mill-turned-brewery revival is bringing life back into these buildings that have lied vacant for years, and Whaler's, while only having received its license in January, is helping to innovate and modernize the local brewery experience.

Nautical-themed breweries run rampant throughout New England. While Whaler's is indeed of the maritime variety—you'll pick up on this by the harpoons and barnacle-encrusted scuba masks adorning the brewery— its callback to whaling is more reminiscent of the hardy New England work ethic, something to which the owners aspire. It also helps that co-owner Josh Dunlap spent years on a commercial fishing boat. "My brewing experience

started in the Marine Corps," said Josh. "It was pretty awful beer. We were probably pretty toasted most of the time, but then I started brewing at home and it turned into an obsession." Josh's brewing savvy grew, and in 2010, he hooked up with longtime friend Andy Tran to create their own hometown brewery. Andy brings years of engineering and design know-how to the table, along with experience in helping to build several other startup companies. Roles were set—Josh would work as brewer, and Andy would function as the man behind the curtains, helping on an administrative level, as well as designing the brand. Cut to Warwick, where Wes Staschke was working on starting up his own brewery. After meeting Tran and Dunlap online, the group realized that they could benefit more by combining efforts, and in 2013, Staschke was brought on as a Whaler's partner and brewer.

"We've generally tried to scrape everything together ourselves—engineer, design, specify and build to what we need," said Andy. "When you start a brewery, you're just not a brewer anymore. You're a carpenter, electrician, plumber, janitor," said Josh, laughing.

Along with the benefits of combining brewing equipment, they also view having two brewers as a plus. "It's nice because you get two totally different perspectives," said Wes. "I like wheat beers and lighter session beers. Josh likes big beers, like our American Strong Ale—really flavorful, complex beers. So we can cover a much wider range of styles." Whaler's two flagship beers—the Hazelnut Cream Stout and the American Strong Ale—are in the process of starting a staggered distribution throughout the state. According to Andy, limiting the range of distribution will allow for the brewery to grow into its market at a pace so that it doesn't overextend itself and is able to keep up with demand. Back in the brewery tasting room, four additional beer styles will always be on tap and in rotation. For Josh, it's important to keep experimenting with new offerings, alongside striving to produce the best beer in its class. He said, "We want to keep the market fresh. We want people to be excited for a new beer and to keep coming back."

The Whaler's Brewing atmosphere and the guys themselves have a pretty laidback attitude, but they're not fooling around when it comes to naming their beers. The team has decided to forgo any marketing gimmicks or outrageous beer names, keeping everything straight and to-the-point. "We want people to associate Whaler's with exceptional beer, so we didn't want to come up with some crazy name that doesn't have anything to do with the style or the characteristics," said Wes. "We don't want people to have to explain the beer or people ordering it because it says, 'Kalamazooshoobittybop.'"

Left: It will be a happy day when full pours are allowed in tasting rooms. Until then, Whaler's is the spot to enjoy some samples. *Ashleigh Bennett.*

Below: Wes of Whaler's Brewing hands out samples at the Rhode Island Brew Fest held at the Kennedy Plaza. *Gray Matter Marketing*

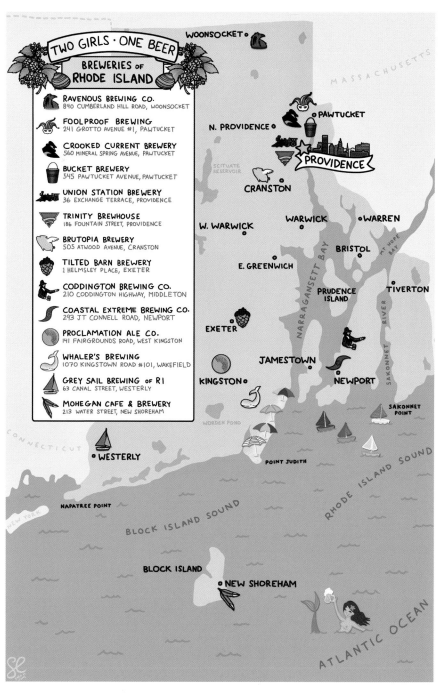

Map of Rhode Island breweries. *Sara M. Lyons Art & Illustration.*

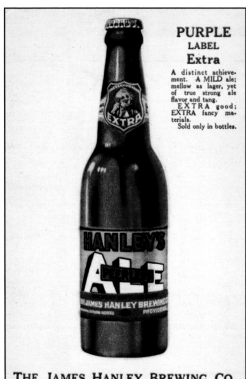

PURPLE
LABEL
Extra

A distinct achieve-
ment. A MILD ale;
mellow as lager, yet
of true strong ale
flavor and tang.
EXTRA good;
EXTRA fancy ma-
terials.
Sold only in bottles.

THE JAMES HANLEY BREWING CO.
Providence Rhode Island
BREWERS OF ALE and PORTER

Left: A marketing campaign ahead of its time—if you want a pale ale, grab a red bottle; an extra ale, take a purple. *Greg and Ed Theberge Collection.*

Opposite, top: Roger Williams Brewing Corporation operated from 1933 to 1940, with Julius Cabisius as brewmaster. *Greg and Ed Theberge Collection.*

Opposite, bottom: Kent Brewing Company (1933–34) came and went in the years following Prohibition. The short-lived brewery produced Kent Ale and Kent Stout. *Greg and Ed Theberge Collection.*

Below: Brew kettles inside a pre-Prohibition brewery. *Greg and Ed Theberge Collection.*

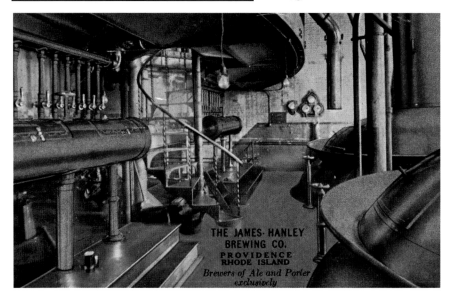

THE JAMES·HANLEY
BREWING CO.
PROVIDENCE
RHODE ISLAND
*Brewers of Ale and Porter
exclusively*

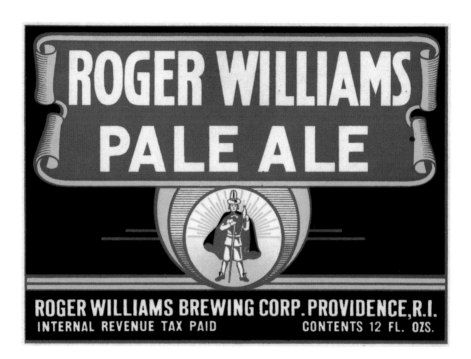

ROGER WILLIAMS PALE ALE

ROGER WILLIAMS BREWING CORP. PROVIDENCE, R.I.
INTERNAL REVENUE TAX PAID CONTENTS 12 FL. OZS.

KENT BREWING COMPANY INC.
West Warwick, R.I.

PERMIT
U-116

CONTENTS
12 FLUID
OUNCES

Kent Ale

TAX PAID AT THE RATE PRESCRIBED BY INTERNAL REVENUE LAW

Made By KENT BREWING CO., INC. West Warick, R.I.

Above: *Greg & Ed Theberge collection, Kristie Martin.*

Right: An original Narragansett coaster featuring the artwork of Dr. Seuss. *Greg and Ed Theberge Collection, Narragansett Brewing Co.*

Opposite, top: Hand Brewing Co. emerged from Prohibition as Rhode Island Brewing under the supervision of bootlegging politician James Lavell. *Greg and Ed Theberge Collection.*

Opposite, bottom: Coddington's impressive sampler tray. *Kristie Martin.*

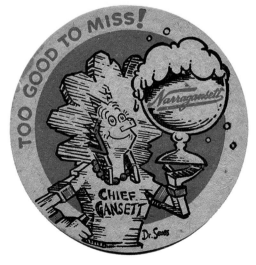

Above: 'Gansett cans through the ages, from the Greg and Ed Theberge Collection. *Kristie Martin.*

Below: Not everyone was literate in 1652, so many public establishments identified themselves with a symbol—in this case, the white horse signified a tavern. *Kristie Martin.*

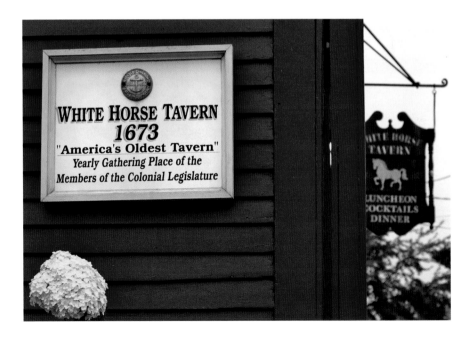

Right: Souvenir from the Newport Craft Beer Festival. *Kristie Martin.*

Below: Music's finest sit down for their last supper in this Trinity Brewhouse mural. *Kristie Martin.*

A look inside the kettle at Middletown's Coddington Brewing Company. *Kristie Martin.*

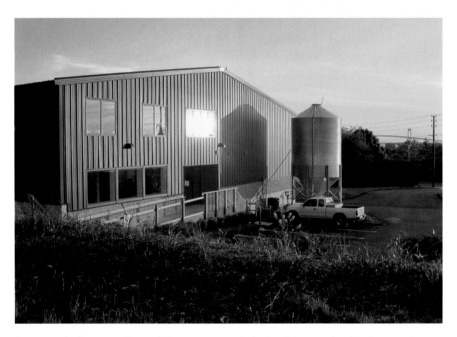

Sunset at the brewery. Coastal Extreme not only is the oldest production brewery in Rhode Island but also is reviving Newport's rum distilling tradition. *Coastal Extreme Brewing Co.*

Above: Trinity's creative spirit is evident even in a pint glass, with the Eye of Providence watching over all who imbibe. *Trinity Brewhouse.*

Right: Bust out your *Bloodsport* VHS for Wham! Bam! Van Damme— Newport Storm's first four-pack. *Kristie Martin.*

Left: Dry, fruity and spicy, with notes of orange peel and black pepper, Proclamation Plattelander has been dubbed "a lawnmowner beer for the sophisticated." *Proclamation Ale Co., Brad Smith Photography.*

Below: Michelle Kirms of Grey Sail presenting the facts. *Ashleigh Bennett.*

*Whaler's
Brewing Co.*

Brewers Derek and Jason borrowing Newport Vineyard's wine press to crush blueberries for Newport Storm's Rhode Island Blueberry beer. *Coastal Extreme Brewing Co.*

Above: This Oktoberfest-style ale is brewed with five German malts, giving it a bready aroma, a nutty malt presence and a touch of caramel (available September through November). *Kristie Martin.*

Left: A view of the 2014 Rhode Island Brew Fest: Summer Edition. *Gray Matter Marketing.*

Right: Founders and friends. *Bucket Brewery.*

Below: The Foolproof can rainbow. *Ashleigh Bennett.*

Left: Bucket is available on draught and in "growlettes," but we recommend going straight to the source and filling up a growler right at the brewery. *Kristie Martin.*

Below: A brewery truly ahead of its time, Emerald Isle Brew Works in Warwick was a leader in the cask ale movement. *Ray McConnell.*

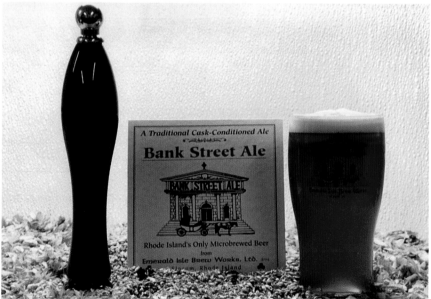

Above: Dave Witham and Nick Sollecito of Proclamation Ale Co. *Kristie Martin.*

Right: Nichole Pelletier and Jason Lourenco of Crooked Current Brewery. *Kristie Martin.*

Left: A collaboration between two iconic Rhode Island brands. *Ashleigh Bennett.*

Below: Hop harvest at Tilted Barn. *Matt Richardson.*

Although the brewery only occupies 1,200 square feet of the 4,500-square-foot former textile mill, they plan on filling the space as they grow. Thus far, reception from the local community has been supportive of the town's first brewery. They'll often see high school teachers from the local school stopping in, as well as people passing through on rollerblades or bicycles. "We're working with all sorts of organizations to build our community network so that we are a fixture within our little town," said Andy. The Whaler's crew is working hard on creating a destination brewery, one where you'll want to spend some time. You can relax in old wooden booths brought in from the Mews Tavern, listen to music or even shoot darts. It gives you the impression of hanging out in a friend's basement—one who happens to always have good beer in his fridge—and it's this experience that they hope will keep people coming back. Josh has positive feelings on everything so far. "I personally hope Whaler's works out for the best and that New England grows with the whole beer scene. I have hope that brewing can get Rhode Island back to a healthy economy."

THE BEER

Meet Whaler's two flagship beers: the Hazelnut Cream Stout, a complex and creamy beer brewed with flaked oats and chocolate malt, and the American Strong Ale, a 9.5 percent beer with a big malt backbone, complemented by six hop additions. The seven-barrel system allows for some brewing experimentation and tweaking of recipes. Some examples of beers you might find include the White IPA, a wheat-based beer fermented with a hefeweizen yeast, giving it a Belgian quality, and the Ginger Wheat, brewed with orange peel, coriander and shredded ginger.

CHAPTER 14

CROOKED CURRENT BREWERY

I may not have gone where I intended to go, but I think
I have ended up where I needed to be.
–Douglas Adams

560 Mineral Spring Avenue, Pawtucket, 401-473-8312
www.crookedcurrentbrewery.com
Opened in 2014

If there's a brewery with a story to tell, it's Pawtucket's Crooked Current Brewery, and it only just made its debut at the 2014 Summer Rhode Island Brew Fest. Owners Nichole Pelletier and Jason Lourenco can tell you that opening a nanobrewery is no easy feat, but through a series of fortuitous events and a little help from the beer gods, the path became clear.

Pelletier returned to her hometown of Narragansett after studying criminal justice at John Jay College in New York. Lourenco, of North Providence, has more than seven years of small business ownership under his belt, alongside a master's from Roger Williams University. "I've always been a beer drinker," said Pelletier. "As I got older, I came to appreciate it more." After years of beer appreciation and brewing their own batches at home, it was a trip to Vermont that sealed the deal and inspired the couple to set out on their own brewery venture in their home state. Pelletier would function as the brewmaster, making her the first female brewmaster in Rhode Island, and Lourenco would oversee the nuts and bolts of the operation, from distribution to recordkeeping.

The mill at 561 Mineral Spring might be a familiar address to some people. That's because before it became Crooked Current, it was the original home of Bucket Brewery before it moved to a larger facility across town. Lourenco recalled, "When we became determined to start this project, I found a commercial real estate website and did an online search. With limited capital and very strict zoning, the parameters that I punched in didn't give back a whole lot of results. There were two places—one in Wakefield and one in Pawtucket. Being familiar with the area, I looked at the Pawtucket listing." In a Google search, the first listing for the address was also Bucket, although the brewery hadn't existed at that location for more than a year. Essentially, there was no reason for a non-active business to be top of the list in a building with more than eight other active businesses. For the brewing duo, these were signs pointing them in the right direction. "From a regulatory standpoint, it was a no-brainer," said Lourenco. "We knew the regulators were already happy with the place. What are the odds that we happened to land in a place that used to be a brewery, with no influence from that brewery?"

As they tell it, the beer gods stepped in yet again when it came time to find brewing equipment. On Craigslist, of all places, Lourenco and Pelletier spied a listing that appeared to be the original Bucket Brewery setup. As fate may have it, Matt Richardson of Exeter's Ocean State Hop Farm (turned Tilted Barn Brewery) had purchased the equipment from Bucket when they left the Mineral Spring address, but Richardson decided to go for a larger brewing operation and put the Bucket gear back up for sale. Lourenco and Pelletier, astonished by their luck, immediately purchased the equipment, knowing that it was already suitable for the space in which they would be working. The Bucket Brewery equipment made its way home to the Mineral Spring mill—like *Homeward Bound*, but with fermenters instead of talking dogs.

As things were falling into place at the brewery, a new challenge presented itself. First, though, we have to take a step back. Before it was Crooked Current, it was Brewery 401. Due to a delay from a keg company, a letter from Connecticut's Stony Creek Brewing Company arrived in the mail before the contract that would have given the brewery a fleet of one hundred new kegs labeled with the Brewery 401 name. The Connecticut brewery produced a (401) IPA, made "specifically for beer lovers in Rhode Island." Although not brewed in Rhode Island, the brewery had a trademark claim on the "401" brand, thus preventing any Rhode Island brewery from using its own area code. Lourenco stated, "I knew of the 401 IPA and, in my naïve mind, thought we could live

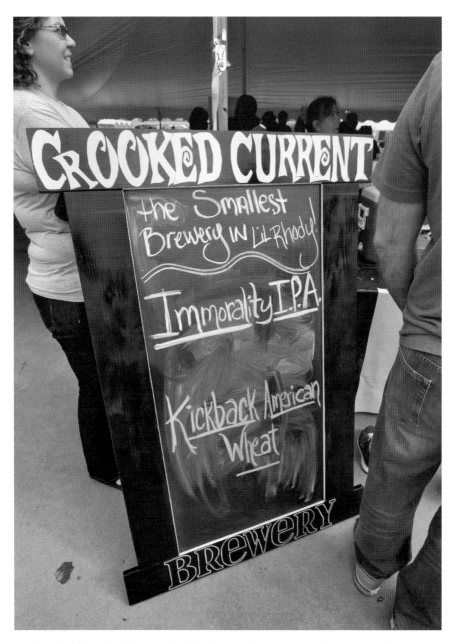

Making their beer fest debut at the Rhode Island Brew Fest in the summer of 2014. *Kristie Martin.*

harmoniously. We were shocked when we got the letter, but it all worked out for the best."

Thankfully, the brewery had another name in mind. Crooked Current was the envisioned company name, but it was put on the backburner, thinking that some may find it too risqué. In a bid to find an iconic Ocean State name, the team went through all the conventional options—lighthouse, clam, ocean—but what struck them as essentially Rhode Island was the state's troubled political history. "Rhode Island tops the list, nationwide, when it comes to corruption. Yes, corruption occurs elsewhere, but if you look back through history, Rhode Island does have a problem even greater than the rest of the country," said Lourenco. The brewery plans to take a tongue-in-cheek look at the history of state corruption through its planned brewery tour experience. "It [the name] has that duality, so if you want to stay family-friendly, it still has the oceanic theme," noted Lourenco. "For people closer to home, they can get a laugh about it."

Although the brewery has only two year-round beers at the moment, plans are in the works for additional seasonals, as well as brewery-only offerings. "Our goal is to turn our weaknesses into strengths," said brewmaster Pelletier. "We have the luxury of a small system to play around on, and I think that'll help when we start doing tours. It'll entice people rather than them having to taste the same things over and over again. If they can always expect something new, something a little different, then that'll keep people coming out."

Both Nichole and Jason work full-time jobs, leaving them one day a week to brew together in the 350-square-foot brewhouse. Precious time is spent tweaking recipes and experimenting with beers that will suit their small setup. "We wanted to find our niche and defeat the archnemesis of nanobreweries, consistency. That's what the past months have been. At the expense of sales, we just want to make sure we have it right," said Jason. If their beer gods keep pushing them in the current direction, they should have nothing to worry about. "It's been a crazy year already, but I know the craziest parts are still to come," Nichole chimed in. "We're having fun with it though."

THE BEER

Even the beers at Crooked Current are named strategically, reflecting the brewery's satirical look at corruption. Kickback is an American wheat,

fermented with a clean ale yeast in order to avoid upstaging the wheat malt; it's incredibly smooth and crisp. Immorality is a 6.5 percent IPA designed to showcase the origins of IPAs through its use of English bittering hops; it's moderately bitter, with notes of grapefruit and pepper. Winter 2014 saw the seasonal release of Plunderdome, a pumpkin maple ale, and Extortion, an eggnog milk stout.

CHAPTER 15

TILTED BARN BREWERY

Ol' man Simon, planted a diamond. Grew hisself a garden the likes of none.
—Shel Silverstein

1 Hemsley Place, Exeter
Opened in 2014

When people think of hops, it's usually the taste of a face-melting West Coast hop bomb that first comes to mind. They envision the expansive farmland of the Pacific Northwest and hop farm workers jumping rope with the sprawling green vines, glass of beer in hand. What most people don't know is that New England used to be the country's hop epicenter. According to Lauren Clark's New England beer opus *Crafty Bastards*, from the mid-1700s until the 1830s, Massachusetts was actually the leading hop producer in North America. Hops have the appearance of little pine cones and grow on vines that can stretch as tall as twenty-five feet. They contain acids and essential oils that add flavor, aroma and bitterness to beer, as well as acting as a natural preservative. As people moved west and began growing hops throughout California and Oregon, local brewers snubbed them in favor of shipping New England hops from across the country. Unfortunately, similar to what happened with barley, people began to realize that the Northwest hop crop rivaled the hops coming from the East. One thing led to another, and as the hops continued to move west, they eventually stayed there.

Over the past decade, small farmers in New England have begun to revive the area's hop industry. Since 2007, brothers-in-law Matt Richardson and Joel Littlefield have operated Ocean State Hops, Rhode Island's first commercial hop farm, out of their family-owned farm in Exeter. Said Richardson, "I was homebrewing for a while, and around 2007, there was a big hop shortage, so I figured I'd put some hops in just for myself because it became harder to get the varieties I wanted." Each year, they put in more and more, eventually narrowing the selection down to four varieties that grew well in the area: the spicy Chinook, the flowery and citrus-forward Cascade, the herbal bittering hop Nugget and the pungent, lesser-known Newport hop. "We thought if we grew some Newports, Newport Storm would be interested. It didn't work out that way. They didn't like the Newport, but they did like the Chinook," Richardson said. Newport Storm brewmaster Derek Luke even went so far as to pick the Chinook crop himself and used it to dry-hop the brewery's India Point Ale IPA (dry-hopping involves steeping the hops in beer during the conditioning process, or basically at any point after the wort has cooled, in order to maximize flavor and aroma). One of the problems hop farmers occasionally run into in the region is the presence of downy mildew, the product of humidity. Ocean State Hops found itself in an optimal location—being surrounded by acres of farmland allowed for wind to pass through the crops, keeping the moisture levels down.

Initially, the crew grew hops strictly for commercial use, marketing themselves to local brewers. As the demand from homebrewers and people brewing on a smaller scale grew, the idea came along to let farm visitors pick their own hops. Pick-your-own was a success, allowing the farmers to cut down on the amount of time spent packaging hops, along with giving people a full farm-to-pint experience as they harvested their own ingredients.

After a seven-year run, owner Matt Richardson has decided to change gears, all while keeping the family farming tradition alive. "Long term, it's not really economically feasible to have just a couple acres of hops and sell them mostly wholesale. You don't get much return for all the work you put into it. So, that made me think instead of selling all these hops for less than it costs us to grow them, why don't we keep them and use them ourselves and put them in the beer and market the beer that way, as a farm brewery," Richardson said. With that, Ocean State Hops is set to be reborn as Titled Barn Brewery, moving a mile up the road to the thirty-acre farm and barn owned by Matt and his wife, Kara. The namesake barn has been in the family for over fifty years, dating back to the early 1900s. It has served many purposes over the years, from horse stables to a

Local brewers are lobbying for a bill that would allow farm breweries that grow their own ingredients to sell unlimited beer to the public. *Matt Richardson.*

woodworking shop and, now, a brewery. Plans are to focus on hoppy beers first and foremost, with brewery tours showcasing not only the brewing process but the growing process out on the farm as well. "We're trying to use a lot more from our farm than just the hops in the beer. We have maple trees, so we'll make maple syrup to be incorporated into the beer. We'll grow pumpkins. We'll have something for every season of the year. One thing from the farm will hopefully come into each beer," said Richardson.

He continued, "I'm so excited to have this big Rhode Island beer scene now, but it's almost to the point where you already need to differentiate yourself right away because there are so many small breweries popping up. I think we're in a good spot to do something unique." After renovating the barn and maneuvering through the licensing process, the Richardsons' plan was to start brewing full scale by the winter of 2014. The brewery's two-barrel system, complete with four two-barrel fermenters, will be able to produce around four barrels per week.

Richardson was initially hoping for a state-level farm brewery license, something that every state in New England has except for Rhode Island. To

the state, Tilted Barn is still considered a manufacturer brewery, meaning it is only allowed to sell up to seventy-two ounces of beer, unlike farm wineries, which are allowed to sell unlimited product.

THE BEER

Tilted Barn opened for the public on November 22, 2014, with a line out the door of patrons braving cold winds for a taste of Rhode Island's first farmhouse-brewed beer. On tap were jack, an amber ale brewed with pumpkins; Half-Mile IPA, full of American citrus hops; and First Harvest: Pale Ale, part of the Barn's First Harvest series. It plans to kick off 2015 with some new beers, as well as make its beer fest debut at the Rhode Island Winter Brew Fest.

THE RHODE ISLAND BREW BUS

www.therhodeislandbrewbus.com
401-585-0303

There's no better way to spend a weekend than touring breweries, but even in a small state like Rhode Island, that requires lots of driving, which isn't the best idea when combined with a day of brewery-hopping. Enter the Rhode Island Brew Bus, an innovative alternative to drawing straws for a designated driver.

Owner Bill Nangle, who studied entrepreneurial management at URI, became interested in craft beer and homebrewing after turning twenty-one. After speaking with the owners of the Maine Brew Bus during his senior year, he decided that he wanted to start his own business and be a part of an industry that he loved. He bought a charter bus from a private school. "I painted it before we even had approval," said Bill. "I wasn't going to let anyone stop me." In 2014, the Brew Bus was open for business.

A day trip on the brew bus is more than just touring different breweries; riders are given snacks, water and markers and whiteboards to play beer trivia. Additional tour guides Eric Nuglow, a member of

A boy and his bus. *Bill Nangle.*

the Rhode Island Brewing Society, and Jon Lanctot teach the patrons about beer and answer any questions. Of course, the bus is also designed to cater to the subtle nuances of the industry—there is a cooler to store growlers and bottles of beer for later, as there is no drinking allowed on the bus.

When it comes to the tours, Bill said, "Everyone shows up as strangers and leaves as friends." The bus hopes to eventually include every local brewery in its itinerary and hopes to grow with the industry, potentially adding another bus to the company within the next few years. The current tour lineup includes:

- The Border Jumper on Friday afternoons, which starts at Grey Sail and then heads into Connecticut for Cottrell Brewing Co., back into Rhode Island for pretzels and beer at the Malted Barley and then back into Connecticut for Beer'd Brewing Co.

- A BEEReakfast of Champions tour on Saturday mornings. Everyone meets at Trinity and then heads to Bucket Brewery and Foolproof and then to Woonsocket's Ravenous Brewing, then back

to Trinity, receiving a 20 percent coupon for a meal. Riders get to take home pint glasses from all the breweries.

- *Afternoon Delight* tour on Saturday afternoon. This tour starts at Sons of Liberty Spirits in Wakefield for a whiskey/vodka tasting and then moves to Proclamation Ale and Whaler's Brewing.

- *Get the Pell Over Here!* Sunday afternoon tour. This tour pick-up is at the Jamestown Bridge. Then it heads over the Pell Bridge into Newport. The first stop is Newport Storm for a beer and Thomas Tew for a rum tasting, then Greenvale Vineyards for a wine tasting and finally Whaler's Brewing. This tour includes craft beer cupcakes made by Bad Kat KupKakes.

Tours range in price from sixty-seven to seventy-seven dollars (depending on the stops and whether food is included).

CHAPTER 16

THE BREWING COMMUNITY

For a long period of time, the few breweries in Rhode Island were stuck brewing solely for vacationers. Breweries like Newport Storm, which prides itself on quality product over marketing gimmicks, found themselves with innovative beers but lacked the promotional aspect that people expected. "We like doing it [releasing new beers]. We don't feel like we have to shout from the rooftops that we're doing it, and unfortunately, in the business world, the image comes first," noted Brent Ryan of Coastal Extreme Brewing Company. Fortunately, the aphorism "a rising tide lifts all boats" rang true as the beer community grew. Today, Rhode Island breweries are able to brew the beers they want to brew, as the "drink local" mentality grows among locals and tourists alike. It becomes conceivable that beer drinkers can limit their consumption to all Rhode Island–based products, whereas in the past, store owners had to explain to people that Pawtucket Patriot Ale wasn't real and that they were basically out of luck for a locally bottled brew. Out of this growth is an expanding beer culture that stretches beyond the breweries themselves.

RHODE ISLAND GIRLS PINT OUT

If you went back in time two hundred years and told people that beer had turned into a man's game, you'd be that alien creature with a time machine talking crazy talk. Brewing beer was on the list of a woman's

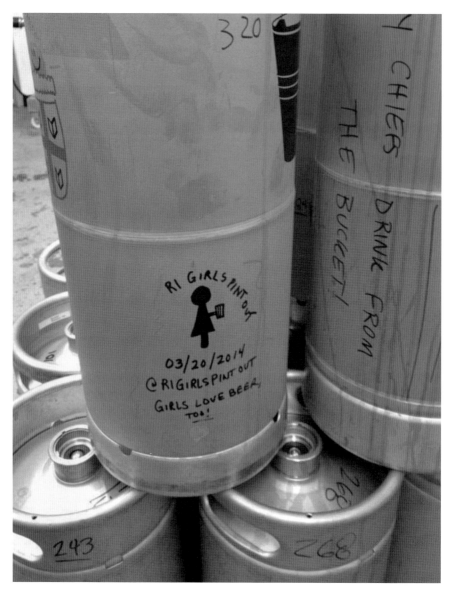

Spreading the good word on a keg of Bucket beer. Brewery tours are one of many events hosted by the local Rhode Island chapter of GPO. *RI Girls Pint Out.*

household duties alongside cooking and cleaning. It wasn't until around the Industrial Revolution of the 1700s that men finally began to find ways to commercialize and industrialize beer and women were gradually pushed out.

In 2013, the percent of women who named beer as their favorite beverage rose to 28 percent—rather significant when you consider how most beer is marketed directly to men. Across the country, organizations like Girls Pint Out are springing up, with the purpose of bringing together women who love beer. The first chapter of Girls Pint Out (GPO) started in Indianapolis in early 2010. Today, there are more than forty-five chapters in more than twenty-five states. Through monthly events, GPO gives women the opportunity to become active in their local beer communities and meet people who share the same passion.

Meredith Crane, founder of the Rhode Island chapter of GPO, moved to Providence eight years ago. She noticed how the beer industry had flourished in many other New England states, but Rhode Island seemed to be on the back end of the movement. "This was always really surprising to me, given the strength of the foodie and locavore culture here," Meredith noted. At a Massachusetts GPO event, she talked with other women about the growing craft beer scene in Rhode Island and how it would be a perfect time to start a beer club. The group's first event was held in June 2013 at Stock Culinary Goods in Providence, combined with a beer tasting by Campus Fine Wines. Since then, the chapter has gone on brewery tours and tastings, teamed up with local food trucks to create beer and food pairing events and worked with other Rhode Island–based organizations such as the PVD Lady Project and Urban Greens Food Co-Op. GPO works to support the local craft beer and food scene, all while uniting people over a common interest. "While beer education is certainly a component, the overall vibe of GPO is more one of bringing together women in a low-key environment where they can meet new people and have fun geeking out about beer," Meredith said. Check out their Facebook page for information on monthly meet-ups and events.

THE BREWERS GUILD

Founded in 2010, the Brewers Guild consists of brewers and brewery owners of most every Rhode Island brewery and brewpub. With a focus on issues such as legislation, marketing and promotion, the Rhode Island Brewers Guild is a way for local breweries to share ideas and promote their interests, as well as widen the state's beer culture. "The challenge for brewers is that for decades the only voice at the state level in the alcoholic beverage world has been the retailer and wholesalers, with a little bit of the winery element.

For this reason, the regulations have been written without much thought for brewers. We are looking to work with the state to bring in the voice of the brewer and show them how valuable our growing industry can be," said Brent Ryan. Already, the guild has seen the passing of a bill that allows visitors to leave facilities with limited amounts of beer or spirits made on-site. More recently, guild activities have focused heavily on beer festivals, such as the Newport Craft Beer Festival and the Rhode Island Summer/Winter Brew Fests. The wheels are also turning on launching a website, as well as establishing a Rhode Island Beer Trail.

According to the Beer Institute, a national organization that represents the beer industry, beer was responsible for 3,430 jobs in Rhode Island in 2012, through brewing, distribution and retail. Whaler's Brewing Company is one of the newest members of the guild, as well as the youngest. Co-owner Andy Tran provides a new voice as to how he envisions the local beer scene. "Whaler's isn't just a brewing company. It's also a small business in Rhode Island. We're trying to create that beer culture and make Rhode Island's libations economy something that is as nationally recognized as our food and restaurant business. There's no reason why those two things couldn't go hand in hand," said Tran. For more than ten years, Rhode Island was the land of one production brewery. Then, in one year, the state saw the arrival of not one but five new breweries, each with its own unique brewing philosophy. For a state known for its culinary ingenuity, it's no surprise that brewing would finally catch up with the impressive food scene and locavore movement. Tran continued, "I think it's a fantastic time to be open. The community is there. It's just going to require exposure, education and some really strong-minded companies."

Market oversaturation and competition is something that comes to mind for a lot of people upon seeing such impressive industry growth. What we've noticed through talking to these breweries, though, is an attitude not of competition but of cooperation. The Brewers Guild is essentially following an anti-business model. Brewers share advice and supplies with one another, all under the mutual goal of improving the state's reputation as a beer-producing state. So far, it seems that all the breweries have managed to carve out their own niches without stepping on one another's toes. Nate Broomfield, co-owner of Bucket Brewery, said, "There are plenty of bars that don't have any Rhode Island beer available. The big fight isn't between ourselves, but is to build an interest in local beer. We're letting people know that you're getting great beer from your home state. Be proud of that. Ask for it. Buy it. That's key."

Rhode Island Brewing Society

The Rhode Island Mini Maker Faire is held every year in downtown Providence. A celebration of New England DIY, the faire is a place for people to show what they are making and share what they're learning—from homesteaders to scientists, as well as the occasional brewer. This is where the Rhode Island Brewing Society (RIBS) got its start. "We've done a live homebrewing demonstration every year there," said President Charlie Baron. "People seem to either love or hate the smell of beer brewing." What started as a small group of friends meeting up to drink beer has grown to around twenty-five, with monthly meetings held in conjunction with brewery tours and brew days. RIBS is spreading beer education and the love of homebrewing, working to educate the community on the art of brewing, as well as grow as brewers themselves. Baron noted, "When we first got started, it was pretty easy to get a table at a bar to have our meetings. After we exhibited at a few events, we started growing in numbers, and without any structure, the meetings just started getting out of hand." The group established a simple hierarchy by voting in a president (Charlie Baron), vice-president (Chris Meringolo) and secretary (Dennis Armstrong), with elections held each November.

The group has participated in events such as the Rhode Island Brew Fest, where it was able to serve some homemade beer, and the Homebrewer's Jamboree, where homebrew clubs from all across New England have gathered for the past eighteen years to taste wares and compete in brewing competitions. About a year and a half ago, RIBS began hosting its own informal quarterly brewing competitions as a way to educate members on how beer judging is performed and simply to keep everyone brewing. Each competition has a theme, usually centered on the season or a category from the Beer Judging Certification Program (BJCP) guidelines. Previous competitions have produced innovative beers such as a blood orange wheat and a cucumber ale.

As the demand for locally brewed beer grows in Rhode Island and as the amount of in-state beer continues to expand, having a beer advocacy group like RIBS becomes more important. Where breweries previously provided their flagship beer along with one or two other offerings, now consumers have their pick from seasonals, one-off series and other special releases. "I think one of the keys to avoiding a bubble burst is to keep putting out quality product," said VP Chris Meringolo. "Education is also important. Teach everyday customers how to recognize a wolf in sheep's clothing. I'm not saying they shouldn't drink a Blue Moon ever—it's not a bad beer—but know where your beer comes from and who made it."

Homebrew clubs are thriving across the state. Brickyard Wine & Spirits in Barrington hosts the East Bay Home Brew Club, which provides regular tastings and field trips. JbreW, a student-run brewing club at Johnson and Wales University, was founded in 2004 and boasts more than one hundred members, including students, faculty and staff. Members engage in homebrew competitions and get to try their hand at brewing in the JWU brewing lab, which holds copper-clad five-gallon brew tanks.

THE FESTS

The beer festival is, for some, the chance to experience new breweries, meet the brewers and gather around other likeminded folks. For others, it's an attempt to justify the ticket price by seeing how many times they can refill their four-ounce sample cup. Thankfully, beer festivals in Rhode Island usually lean toward the former, serving as charitable events and as showcases for new breweries. The benefits of having a small brewing community result in numerous well-planned festivals that serve to highlight the local food and beer scene.

The Newport Craft Beer Festival is held every spring on the grounds of Newport's Great Friends Meeting House. Built in 1699, the building is the oldest surviving house of worship in Rhode Island. Proceeds from the event go to the Rhode Island Brewers Guild, as well as the Newport Historical Society. Being a guild event, the Rhode Island breweries have their own section under the tents, so you can walk the local brew gauntlet before making your way to the rest of the breweries. Food is provided by local restaurants, so you don't have to rely on pretzel necklaces as sustenance. Overall, it's hard to think of a better way to spend a day in Newport.

Summer in Rhode Island provides plenty of festival options. Rhode Island Brew Fest, hosted by Gray Matter Marketing, is a well-attended event that features up to thirty breweries, live music and local food. The festival has been held in conjunction with Craft Brew Races, a 5k for runners and walkers held in multiple cities throughout New England. A winter edition of the Rhode Island Brew Fest is also held every February in Pawtucket. What's refreshing about these festivals is that there are no booth fees for brewers. They are actually paid to participate, on top of donating a portion of ticket sales to the Rhode Island Brewers Guild. Brew at the Zoo, held each September at Roger Williams Park Zoo, is a large event

complete with animal encounters—really, what more could you want? Proceeds go toward conservation programs and zoo improvements. The East Bay Beer Fest (EBBF), organized by the crew at Brickyard Wine & Spirits, had its second anniversary in June 2014. Held in Warren alongside the waterfront Blount Clam Shack, EBBF is another festival that serves as a fundraiser, as well as specializing in local breweries and featuring on-site brewing demonstrations. The Great International Beer Festival is the largest beer festival in the Northeast, held every fall at the Rhode Island Convention Center. The event also serves as a competition, with judges handing out awards for the best beer in each category.

Beervana, as the name implies, is not just a tasting event. It is a festival with a mission to enlighten and educate the community for the responsible appreciation of craft beer. It is a space to sample the best the beer world has to offer, from the unique to the hyper-rare, including beers brewed exclusively for the event, all poured by industry pros. Two beer seminars are also included in each Beervana, with past guest speakers including Sam Calagione of Dogfish Head; Tod Mott, previously of Portsmouth Brewery and now with his own Tributary Brewing Company; and Dave Engbers, co-founder of Founders Brewing Company.

Held at the historic Rhodes on the Pawtuxet in Cranston, the festival entered its sixth year in 2014, and each year it continues to up the bar thanks to the knowledge and dedication of event organizers Mike Iannazzi (co-owner of Nikki's Liquors) and Brian Oakley (Julians' general manager). "It's like an art show for beer," said Oakley. "The rule is you cannot bring your flagship. We hand-pick every beer to help curate the show, as well as pay breweries for their beer."

If you have a beer close by, we'd suggest you crack it now because you'll probably be feeling a bit thirsty after seeing some of the beers from past festivals. The year 2014 saw a vintage batch of Dogfish Head's raspberry juice–infused Fort; Sierra Nevada pouring all twelve Beer Camp collaborations; the Quahog Special Ale, brewed exclusively for Beervana by Southern Tier; and many sought-after gems from importers B. United and the Shelton Brothers, as well as the estimable Founders KBS. Not to leave out the local guys—Newport Storm debuted its Annual Release '14, brewed with 1,300 gallons of melted snow from a rare Newport snowstorm, alongside a classic hefeweizen yeast. Revival Brewing Company's White Electric Coffee Stout, made with New Harvest coffee beans and served on nitrogen, is a beer you would probably find yourself choosing over coffee every morning, if your life is absolutely void of any responsibilities. Proclamation Ale and

Grey Sail also teamed up to create Jelly Donut, a traditional Berliner Weisse paired up with some unique syrups.

Beervana also serves as the culmination to Providence Craft Beer Week, held every October since 2010. A celebration of a city with a rich food history and a growing beer community, Craft Beer Week features dozens of tastings, beer dinners, tap takeovers and meet-the-brewer events at bars and restaurants throughout the city.

ONWARD AND UPWARD

The coming years promise to bring rapid expansion. Love it or hate it, Shipyard Brewing Company and its infamous line of seasonal beers and English-style ales will be making a home for itself at Twin River Casino in Lincoln come the end of 2014. Shipyard is the fourteenth-largest craft brewery in the United States, with its flagship brewery in Portland, Maine, and satellite bars throughout New Hampshire, Maine and Florida. In Providence, Jeremy Duffy and Devin Kelly are working through the logistics of opening Isle Brewers Guild, a contract brewery with a planned capacity of sixty thousand barrels per year. Isle Brewers would serve as a brewing space for smaller breweries that are lacking the equipment to brew in large volume. Duffy is holding off on releasing any additional information, but sources say that the partners aim for an opening in the second half of 2015. We also continue to wait with bated breath for any news from Mark Hellendrung and Narragansett Beer on the brewery's triumphant return to Rhode Island.

Drinking Sherpa, based out of Woonsocket, has launched itself as what it calls the "first technology-based libation tourism company." By partnering with breweries, wineries and distilleries, it has created an app and a website for tourists to create their perfect libation vacation by providing a central resource for brewery hours, prices, products and more.

The craft beer audience continues to grow, and so does the demand for new beers. Local brewers are learning to change with the times, continually expanding their knowledge and testing the waters. We feel like we're in on this big secret—the fact that there is fantastic beer coming from the country's smallest state. As we wrote this book, the Rhode Island beer landscape was shifting. The newest breweries are opening up tasting rooms and growing into their distribution range. Older breweries are upgrading

Proclamation Ale shirt. *Kristie Martin.*

equipment, expanding their existing facilities and extending their hours. Brewery taprooms are beginning to feel less like warehouses and more like neighborhood speakeasies, places where you can spend some time, sampling beer and meeting new, likeminded friends. Because of its size, the Rhode Island beer community feels less like an industry and more like a group of friends with one goal in mind: to drink good beer. It's refreshing and welcoming, and it isn't showing any sign of slowing down.

CHAPTER 17

A Guide to Rhode Island's Best Beer Bars

The Avery

18 Luongo Square, Providence

There's no sign adorning what looks like a boardinghouse tucked away on a Federal Hill side street. You're hesitant upon stepping inside. It's dimly lit, like a Prohibition-era speakeasy. You might need a password to enter, who knows. Owner John "J.R." Richard has created a bar with a one-of-a-kind ambiance. With its varnished woodwork and stunning, backlit woodcuts, you'll want to take your mescal Old-Fashioned and sink into a leather couch forever. And yes, I said an Old-Fashioned. The Avery is known for its unique cocktails made with care by very knowledgeable bartenders. Fret not, you suds-heads—the beer list is top-notch as well.

While you're in the neighborhood, we recommend hitting up the trifecta, starting with drinks at The Avery, followed by dinner at North, a Momofuku-style restaurant fueled by some creative young chefs, and ending at E&O Tap. It's a great way to make your date think you have excellent taste.

DOHERTY'S EAST AVENUE IRISH PUB

342 East Avenue, Pawtucket
401-725-9520

We were both a bit skeptical during our first visit to Doherty's. Irish pubs have never really been synonymous with craft beer. We thought that we were in for an evening of Killian's and shepherd's pie, but lo, this is not the Irish bar we had envisioned. Yes, you can watch multiple sports games at once, and yes, it's a bit rough around the edges, but all of this adds up to a casual and unpretentious attitude that ultimately feels quite charming. The staff is accommodating and attentive, adding to the welcoming environment.

The draft list at Doherty's is unmatched—featuring a daunting menu arranged according to style, as well as a Just Tapped and Last Chance listing. The taps are heavy on New England offerings from breweries like Cape Ann, Smuttynose and Sebago but with local options like Foolproof and Newport Storm also peppered in, as well as some unique beers from Lagunitas, North Coast and Victory. The bottle selection branches out even more to include some larger formats from renowned breweries, as well as a small Belgian offering. Flights are available for the indecisive drinker, and if your liver needs a punishing, you can join the Beer Club to earn prizes for drinking your way through the tap list.

Sunday brunch features pitchers of mimosas and Bloody Marys (our go-to beverage when beer isn't looking), but our favorite night is Monday, which is Doherty's featured brewery night and will often include a pint-night or a tap-takeover, alongside fifty-cent wings.

If you're looking for more of an upscale dining experience, check out Doherty's Ale House in Warwick. You'll find the same one hundred plus taplines of craft beers, focusing on breweries between Maine and Maryland, but the food menu shifts from stick-to-your-ribs pub food to a smaller, more gastropub-like offerings.

E&O TAP

289 Knight Street, Providence
401-454-4827

If you size up the E&O by its exterior, you'll probably end up walking in with expectations lowered, envisioning a Boston Lager in the near future on

this quiet West End side street. This is all quickly thrown out the window upon entering. The tap list is loaded with good American crafts, with a few Belgians thrown in. Your eyes can't stop wandering as you take in the décor, a mix of old-time breweriana and a Savers shopping spree. Pinball machines are tucked in the corners, and a large projector drapes one wall, usually playing stand-up comedy, sports or movies. The weekends are packed—fun and loud with no shortage of good music and the occasional crawfish boil on the back patio. It's not a big place, but it's comfortable—a great neighborhood bar with character.

Grad Center Bar (GCB)

42 Charlesfield Street, Providence
401-421-0270

To anyone looking to open up a bar, if you want it to become a beer fan favorite, put your business in a place where nobody can find it—a hall of mirrors, at the bottom of the ocean guarded by mermen, in Hogwarts' Room of Requirement (hey there, Harry Potter fans). If you find yourself in a residential neighborhood, knocking on doors, asking if the bar is in there, you know it must be good! GCB is located in the basement of the Graduate Center complex on the Brown University campus. Make your way down the stairs and through the hallways, and you'll be greeted by one of the best bars in Providence.

If you're a Brown or RISD student, you have free membership to the bar; otherwise you'll have to pay a small fee or purchase a yearly membership. Don't fret, though—what you pay in admittance, you'll make up for with the very cheap drinks. GCB is a nonprofit private organization, which helps to keep prices low, meaning high-quality beers for about five dollars.

The dimly lit subterranean bar is divided into a few rooms, one main lounge area and some smaller side rooms for darts and pool. The drafts are some of the best in the state, and you can't leave without picking out a bottle from the well-stocked cooler. Small food options are available as well—cheese plates, chips, popcorn and so on, all for just a few bucks.

What's especially great about the GCB is that even if you've never been before, the bartenders treat you like regulars. They're all incredibly knowledgeable and personable, always with a drink recommendation up

their sleeves. Swarms of college kids can make late weekend nights a bit tedious, but when you have the place to yourself on an early evening, you're really never going to want to leave.

JULIANS

318 Broadway, Providence
401-861-1770

It's hard to think of something to say about Julians that hasn't already been said. For twenty years, the restaurant has been a West Side landmark. Located under an unassuming awning on Broadway, you'll likely walk by if you haven't been before, but if it's the weekend, there's no missing the line out the door of people looking for the best brunch in Providence and a bit of hair of the dog.

Some may say, "Oh, it's just a hipster hangout." If being a hipster means wallowing in the ability to watch He-Man in the bathroom, pound Gulden Draaks and Saison Duponts and eat house-smoked salmon Benedicts until we fall off our chairs, then color us flannel because we could live here.

Julians has a bistro vibe complemented by an eclectic décor and artwork by local artists. A large open kitchen pushes out items such as house-made tempeh sausage

Julians. *Kristie Martin.*

(did we mention this place is a must for vegetarians/vegans?), pumpkin-almond pancakes with candied pepitas and Bloody Mary burgers (topped with horseradish chips, smoky bacon and Bloody Mary ketchup), alongside a specials menu of constantly rotating types of tofu, hash, pancakes and omelets. Prices are reasonable, and the staff is always extremely welcoming and friendly.

What we're sure you really want to hear about is the beer, though, and Julians has one of the most unique draft lineups in the state. Imports from Brouwerij Vanhonsebrouck, Schneider and Slaapmutske grace the lines next to special offerings from Allagash, Dogfish Head or Stone. In bottles, you might come across De Struisse, Alesmith, Jolly Pumpkin and a few Trappists (try our favorite, Orval, the only Trappist beer brewed with Brettanomyces). The amount of thought put into the beer selection at Julians is apparent. For the beer-adventurous, or if you're just looking for a great lunch, Julians is not to be missed.

THE MALTED BARLEY

42 High Street, Westerly
401-315-2184

Our first time at the Malted Barley, we weren't sure what to expect. "Should we get dinner first? They only serve pretzels." We apologize for ever doubting you, Barley. Once you settle into your seat, you realize that you don't need anything else in the world besides beer and pretzels.

Opened in 2011 by local couple Colin and Stephanie Bennett, the Malted Barley is an impressive and welcoming building. With an exposed brick and beam interior, a bar you can't see the end of and a gorgeous outdoor patio overlooking the Pawcatuck River, definitely plan to set aside a few hours of bar time.

Choose your pretzel (Asiago and parmesan, caraway seed, stuffed jalapeño and cheddar are some options) and then pair it with a dipping sauce (blue cheese, beer mustard, apricot butter, Nutella). Soups, sandwiches and desserts are also available, all using the same house-made pretzel dough.

When it comes to choosing a beer to pair with your pretzel, don't hesitate to ask one of the bartenders. They all seem like they actually want to

hang out and chat with you about beer and are always on point with their recommendations. Thirty-six taps line the Malted Barley, assisted by a well-organized list arranged according to style and a nice selection of bottled beers. Don't forget to ask for your Down the Line card!

MEWS TAVERN

456 Main Street, Wakefield
401-783-9370

Something about stepping into Mews Tavern makes you feel like you're entering a traditional colonial pub. Maybe it's the rustic décor, blended with the endless number of antique tchotchkes that give the building its timeless quality. It could also be the families sitting alongside the college students, the businessmen mingling with the fishermen. Mews is the place that everyone passes through, similar to the pubs of the past, which served as a home away from home for many patrons. The thousands of personalized dollar bills adorning the walls add to the feeling that if you talk to any South County resident, they can tell you a story about a time at the Mews.

Mews has seen incredible growth since it originally opened in 1947 as a small fisherman's tavern. Today, the restaurant includes a main dining room, complete with its own beech tree growing through the center of the room; a Celtic-style upstairs bar featuring more than two hundred single-malt scotches and forty whiskies and bourbons; and, the most important part, the widely promoted sixty-nine beer taps.

The tavern has prided itself on being a "something for everyone" bar, and that carries over to the beer selection. You can get an Allagash Curieux or an Amstel Light. Local options such as Newport Storm, Grey Sail and Proclamation Ale are often available as well. The food ranges from pizza to Mexican, along with burgers that have been rated as South County's best.

NOREY'S

156 Broadway, Newport
401-847-4971

Norey's was established to help you drink the best beer in the world. That's it. No "gateway" beers, no filler—just straight to the good stuff. For ten years, Norey's operated as mainly a breakfast/lunch spot, with owner Norey Cullen at the helm, serving her renowned desserts. In 2009, Norey's son, Chef Tyler Cullen, stepped in, looking to create a Modern-American bistro for beer and wine connoisseurs. The menu is small and fresh, constantly changing according to season and availability. Prices are surprisingly reasonable, with entrées ranging from thirteen to twenty dollars.

Let's get to the beer, though. The taps are always rotating, but some examples of beers you might see include drafts from Mikkeller, Brouwerij Bosteels, Dieu du Ciel and the estimable BFM (Brasserie des Franches-Montagnes), alongside a few American options like Slumbrew's Flagraiser or Dogfish Head Burton Baton. Treat yourself to a beer from Norey's bottle collection, which is populated with aged varieties, assorted rare Belgians and brewery one-offs. It can all be a bit overwhelming. These are beers you need to sip and enjoy over a lengthy span of time. Thankfully, Norey's warm and inviting atmosphere makes it easy to get comfortable in your seat, as you realize you're not going to want to leave anytime soon.

POUR JUDGEMENT BAR AND GRILL

32 Broadway, Newport
401-619-2115

Located far enough away from the wharf so as not to be too packed with tourists, Pour Judgement is the type of place where you can really feel like a Newport local. The building is narrow—about eight tables and a long bar. You'll be crammed in next to service industry workers and townies, thinking you're in just another dive bar, until you spot that bottle of Maine Beer Company Lunch. The tap list features a lot of American craft beer staples from the likes of Dogfish Head, Founders, Harpoon and Ithaca, along with a nice assortment of larger bottles from breweries such as Clown Shoes, Green Flash and Firestone Walker.

Take advantage of the eight-dollar Beer & Burger Special, and don't forget to ask for the Gouda cheese sauce for your fries.

THE SCURVY DOG

1718 Westminster Street, Providence
401-270-7980

Here's a tiny black box of a building with no windows overlooking the highway. Despite what you may think, this is not a dive bar—it's the Scurvy Dog, and it is awesome. Indoors you can shoot pool, play pinball and drink from twenty craft beer taps, probably while listening to Agent Orange or Motörhead. The outdoor beer garden feels like a cookout at your friend's house. If it's the weekend, the Poco Loco Taco truck is parked out back. If it's Monday, you're probably slamming scorpion bowls. Other bars can call themselves punk rock, but it'll always feel contrived in comparison to the Scurvy. This is basically one of the only bars you'll ever need.

TRACK 84

84 Kilvert Street, Warwick
401-739-8484

This is probably one of the strangest places that we've ever enjoyed craft beer. Coming up from Newport one day, we realized that we were about to hit gridlock traffic heading into Providence, so we decided to pull over and kill some time at a Warwick bar we'd heard about but never visited. We took the exit for T.F. Green Airport and made our way down a dark side street, cursing our GPS as we saw the road hit a dead end by some railroad tracks. Then we noticed the gray building with the front porch that we assumed was the house of someone who would shortly be telling us to get off their lawn, but then we saw the sign.

This is a true destination bar, similar to the likes of some of our favorite hidden Maine haunts like Ebenezer's Pub or Novare Res. You won't casually stumble upon it. There's nothing on the exterior screaming, "This is an

amazing beer bar!" There's really nothing on its worn and simple interior screaming that either. You just have to put your reservations aside and saddle up to the bar, which at this time was full of an older group of locals, drinking bottled beer and watching the news.

Before even looking at the tap list, we saw one lone bottle of Allagash Nancy—a sour red ale brewed with Maine cherries that had been hard to come by in Rhode Island. Tucked away in the bottle fridge was an assortment of hard-to-come-by Belgian beers, as well as some reliable favorites from Unibroue and Rodenbach. As amazing as the beer was, we wished we gave the drafts more attention. That day, some of the choices were De Dolle Dulle Tripel, Dogfish Head Piercing Pils, Sierra Nevada Narwhal, Mayflower's Scotch Ale, Maine Beer Co. Zoe and, the latest, Stone Enjoy By IPA, all being served up in perfectly matched glassware. The bartender handed out free freshly popped popcorn as people took their turn at an arcade game in the corner. Overall, you just feel comfortable here. Owner Dave Longiaru's father bought the building in 1981, and over the years, Dave, a Belgian beer fan, made Track 84 into the type of bar where he would want to drink. Its timeless quality and fantastic beer selection will keep people coming down this dead-end road for years to come.

WHAT CHEER TAVERN

228 New York Avenue, Providence
401-680-7639

Four tables, twelve seats at the bar and an abundance of *Lucha libre* masks—what the What Cheer lacks in space, it makes up for in an abundance of personality. Opened in 2012 by Dave Crockenberg and his wife, Zoe Brown, the What Cheer sees a lively mix of neighborhood folk, Johnson & Wales students and craft beer fans. With twelve well-planned taps and Dave behind the bar, you'll probably end up discovering your new favorite beer. Crockenberg expertly guides patrons through beer styles, pouring out samples of local favorites, strong regional brews and the occasional rarity—none of the "usual suspects." This isn't the place for a Bud Light or an appletini—if you can appreciate that, then you'll probably fit right in. Zoe's innovative and evolving menu blends street food with typical bar fare, often with a Korean or Indian twist, creating

sought-after items such as the Choi Dog, a beef or veggie hot dog topped with gochujang mayo, kimchi and sesame-lime slaw; and the What Cheer Bacon Wing, Baffoni's Farm chicken tossed with smoky bacon hot sauce and crumbled bacon.

Imagine if Glenn Danzig opened up a tiki bar on the South Side of Providence, and you've got the What Cheer. You'll tell yourself you're just stopping in for one, but most likely, you'll end up staying 'til the lights go out with the new friends you've made throughout the night. As Bill Watterson said, "What fun is it being cool if you can't wear a sombrero?"

Cooking with Rhody Beer

W e're not going to lecture you on the strict guidelines of beer and food pairings, but there are a few components to keep in mind when cooking with and pairing beer and food—mainly "complement," "contrast" and "cleanse." Pairings work when you find flavors that complement each other—a sweet dessert will naturally go well with a sweet beer. Exciting pairings also come about when you contrast flavors, like the briny sweetness of an oyster next to the roasted bitterness of an Irish stout. The third element is cleansing or cutting. For example, hop bitterness can cut through rich, fatty foods as well as alleviate spiciness. Cutting can also occur through the beer's carbonation and acidity.

Overall, cooking with beer just makes sense. It's more flavorful than water and more complex than any ready-made stock or cooking liquid. A good dish can potentially become a great dish with the addition of the right beer.

PROCLAMATION TENDRIL-BATTERED FISH TACOS

Proclamation's "not quite imperial IPA" is perfect to pair up with this Baja-style taco. Its big fruit and citrus flavors work to enhance the fish as well as make a unique tortilla.

2 cups Masa
½ teaspoon salt
1 growler of Proclamation Tendril

½ cup mayonnaise
½ cup Mexican crema or sour cream
¼ cup whole milk
1 tablespoon hot sauce (Sriracha works nicely here)
3 limes

1 cup flour
¼ teaspoon garlic powder
¼ teaspoon salt
pinch of cayenne
1 egg

oil for frying
1 pound firm white fish, cut into 2-inch pieces
½ head green cabbage, sliced very thin
1 avocado, thinly sliced
fresh cilantro

To make the tortillas, combine the Masa, ½ teaspoon of salt and 1⅓ cups of beer in a medium bowl and stir until it comes together. If it's too dry, add more beer, one tablespoon at a time, until it comes together. If it's too wet, add more Masa. Gently knead the dough for a couple of minutes and then form into balls a little bigger than a golf ball. Press the tortillas by placing them between layers of plastic wrap and pressing (a large book works here) until the tortilla is about 4 inches in diameter. Repeat with remaining tortillas. Put a large, dry skillet over medium-high heat and cook until slightly browned (about 30 to 50 seconds each side). Cover cooked tortillas with a dishtowel to keep warm.

To make the sauce, combine the mayo, crema/sour cream, milk, hot sauce and the juice of ½ a lime in a small bowl.

In a large bowl, mix the flour, garlic powder, salt and cayenne. Add the egg and 1 cup of beer and stir until combined.

Add a few inches of oil to a large skillet over medium-high heat, ideally getting the oil to about 350 degrees. Dip the fish into the batter, let the excess batter drip off and then place in oil. Cook until golden brown, about 2 minutes on each side, and then remove from skillet and place on paper towels to drain. Season with salt.

Place fish in a tortilla and serve topped with shredded cabbage, crema, avocado, cilantro and lime wedges. Finish what's left in your growler.

Quick and Easy Foolproof Barstool Beer Bread

This recipe from Ashleigh's grandmother makes a hearty and savory loaf of bread that is perfect for toasting and having with some jam or dunking into a stew. We chose Foolproof's Barstool because of its light malt sweetness and slightly toasted quality. Also, because it's a beer you're usually going to drink a few of, we always have some kicking around the fridge.

*3 cups self-rising flour**
½ cup sugar
1 12-ounce can of Foolproof Barstool
¼ cup melted butter

**To make approximately 1 cup of your own self-rising flour, combine 1 cup of all-purpose flour with 1½ teaspoons of baking powder and ½ teaspoon of salt.*

Preheat the oven to 350 degrees. Combine flour, sugar and beer together and pour into a lightly greased loaf pan. Bake for 45 minutes. After 45 minutes, pour the melted butter on top and bake for another 10 minutes or until lightly browned. Let cool before serving.

Park Loop Porter Chili

One of our favorite kitchen secrets—pour a dark beer such as a porter or a stout into your chili. Bucket's Park Loop Porter adds a depth of flavor with its toasted and smoky notes.

2 pounds ground beef or turkey
1 teaspoon ground cumin
1 teaspoon smoked paprika
½ tablespoon ground coriander
2 tablespoons vegetable oil
1½ onions, chopped
2 cloves garlic, minced
1 red bell pepper, cut into ½-inch pieces
2 large jalapeño chilies with seeds, chopped (about ⅓ cup)
¼ cup chili powder
2 (14.5-ounce) cans diced tomatoes with juice
1 can kidney beans, drained
2 tablespoons Worcestershire sauce
12 ounces Bucket Park Loop Porter
optional for serving (but recommended): tortilla chips; sour cream; chopped green onions; coarsely grated, extra-sharp cheddar cheese

Sauté beef, cumin, paprika and coriander in 1 tablespoon of oil and continue to brown until there isn't any pink remaining. Break up the beef as you cook it so there are no large clumps. In another skillet, combine remaining oil, onions, garlic, peppers and jalapeños. Sauté until soft and add into the pot with the beef. Once these are combined, add in the chili powder, diced tomatoes, kidney beans, Worcestershire sauce and beer. Bring the mixture to a boil and let simmer for 20 minutes. Season with salt and pepper to taste. Serve with shredded cheddar, chopped green onions, sour cream and/or tortilla chips.

Narragansett Lager Clambake

Ah, the classic 'Gansett clambake. It's a New England summer staple and the perfect one-pot meal for a night with some friends. We took the traditional recipe and stepped it up a bit with the addition of some of our favorite types of shellfish and an herbed lemon-infused butter.

2 to 3 onions, quartered
1 head of garlic, separated
2 lemons, quartered, plus additional lemons for garnish
2 bay leaves

1 bundle of thyme
1 can Narragansett Lager
1 cup water
1½ pounds small potatoes (new or red work well)
1 pound spicy chorizo, cut into ½-inch pieces
salt/freshly ground pepper
3 lobsters
36 steamers, scrubbed
4 ears corn, husked and halved
2 pounds mussels, debearded and scrubbed
1 cup butter, melted
green onions and parsley, chopped for garnish (optional)

Grab a big 16-quart stockpot. Add the onions, garlic, two lemons, bay leaves, thyme, beer and water. Place a steamer basket on top and add the potatoes and chorizo. Season with salt and pepper. Bring to a boil. Add the lobsters and cook over high heat, covered, for 15 minutes. Next, add the steamers and corn and cook, covered, for another 5 minutes. Add the mussels and cook, covered, until the clams and mussels are open, another 4 to 8 minutes.

Using tongs, remove the seafood, chorizo, potatoes and corn from the stockpot and transfer to a large platter or to a table covered with newspaper. Throw out any unopened clams or mussels. Strain the remaining liquid through a sieve and into a bowl and add the melted butter. Squeeze lemons over the clambake and serve with butter and chopped herbs.

WHALER'S AMERICAN STRONG ALE BEER BRATS

This meal is our own take on a quintessential beer recipe. Not only does it taste good, but once it's dumped in the slow cooker, your work is done. This can be served over sauerkraut or on rolls, but if you add potatoes, it also makes a nice stew.

2 packages bratwurst
1 onion, sliced
3 cubed potatoes (optional)
1 cup apple juice or cider
¼ cup Dijon mustard
½ teaspoon caraway

4 cups Whaler's American Strong Ale
2 bay leaves
salt and pepper to season

Cut small slivers into the bratwurst with a knife to prevent them from bursting while cooking. Place the bratwurst, onion and potatoes (if using) into the crockpot. In an additional bowl, combine apple juice or cider, mustard and caraway. Pour into crockpot, add beer and bay leaves and turn slow cooker to "high" or "medium"; let cook covered for 7 to 8 hours. Stir occasionally. Salt and pepper to taste before serving.

GREY SAIL FLAGSHIP CREAM ALE AND CHEDDAR SOUP

Grey Sail's Flagship is a great addition to this soup and is also a perfect beer to drink with it. The bright hop flavor helps with the spiciness, as well as balancing the richness of the cream and cheddar.

½ pound thick-cut bacon
1 small onion, diced
1 celery rib, diced
2 jalapeños, seeded and diced
2 garlic cloves, minced
1 tablespoon thyme, chopped
1 tablespoon Worcestershire sauce
1 teaspoon Dijon mustard
pinch of cayenne pepper
1 can of Grey Sail Flagship
2 cups chicken broth
4 tablespoons unsalted butter
¼ cup all-purpose flour
1 cup heavy cream
2 cups cheddar cheese, shredded
salt and pepper

Cook the bacon in a large saucepan over medium heat until crispy, about 7 minutes. Reserve the grease and set the bacon on paper towels to drain.

Cut into 1-inch pieces. Add the onion, celery and jalapeño to the pan and cook over medium heat until the vegetables begin to soften, about 7 to 10 minutes. Add the garlic, thyme, Worcestershire sauce, mustard and a pinch of cayenne. Cook for an additional minute. Add half of the beer and cook until it begins to reduce, about 5 minutes. Add the chicken broth and bring to a simmer.

In a small skillet, melt the butter over medium heat. Gradually add the flour, stirring constantly, until lightly browned, 2 to 3 minutes. Whisk this roux into the soup and bring to a simmer. Cook for about 8 minutes, until it begins to thicken. Add the cream, cheese and the remaining beer and simmer for about 5 minutes. Stir in the bacon and season with salt and pepper. If the soup is too thick for your liking, add in additional broth.

CROOKED CURRENT KICKBACK BANH MI

American wheats are incredibly versatile when it comes to food pairings. Their bready wheat sweetness allows them to merge well with the flavors of bright and crisp veggies, especially cukes. They can also stand up to creamy dressings, in this case a spicy mayo. Kickback is a very wheat-forward ale, with a cracker-like quality that works well with a toasty baguette piled high with beer-pickled veggies.

MARINADE:
½ cup soy sauce
¼ cup sesame oil
¼ cup Crooked Current Kickback
¼ cup fresh squeezed lime juice
2 tablespoons rice vinegar
2 teaspoons hot sauce
¼ cup brown sugar
2 cloves garlic, minced
2 tablespoons fresh ginger, minced

QUICK-PICKLE:
½ cup rice vinegar
¼ cup Crooked Current Kickback
¼ cup sugar
¼ cup carrot (about ½ a carrot), peeled and julienned

¼ cup white daikon radish, peeled and julienned
¼ cup red onion, thinly sliced

SRIRACHA MAYONNAISE:
6 tablespoons mayonnaise
2 tablespoons Sriracha
2 teaspoons lime juice
½ teaspoon soy sauce

1 package extra-firm tofu, drained and pressed
½ cucumber, thinly sliced
1 jalapeño, thinly sliced, seeds removed
handful of cilantro
1 large baguette, cut into 4 sandwich-sized pieces

Whisk together the marinade ingredients. Cut your block of drained tofu into 8 slices and then cut those in half to get 16 even squares. Place the tofu in the marinade, making sure it all gets covered. Let the tofu marinate for at least an hour—overnight if you have the time.

Place the rice vinegar, ¼ cup beer and sugar in a small saucepan over medium heat. Stirring constantly, bring the mixture to a boil. Transfer the liquid to a bowl to cool. You can also place it in the fridge while you prep up the other ingredients.

Peel and slice the carrot and radish into matchstick-sized slices. A mandolin slicer comes in pretty handy here. Slice the red onion into thin half-moons. Add the carrot, radish and red onion to the cooled vinegar mixture and mix well. Set aside to marinate for at least 30 minutes. After they've sat for a while, drain off any excess liquid and they're ready to go.

Make the mayo by mixing together all the ingredients until well blended. This is a great mayo to have around the house. We love it on burgers or as a dip for onion rings.

Preheat the oven to 400 degrees. Line a baking sheet with parchment paper and place your marinated tofu on the sheet. Cover generously with the marinade. Bake for 10 minutes, flip the tofu, pour on some more marinade and bake for an additional 10 to 15 minutes, until it starts to crisp.

While the tofu is cooking, prep up the rest of your veggies. Slice the cucumber and jalapeño and wash your cilantro. For the baguettes, it helps to pull some bread out of the center of each piece to make room for the filling. To assemble your sandwich, spread Sriracha mayo onto the bottom

half of the bread (top half, too, if you're feeling wild). Layer on some cucumber slices and tofu and top with the pickled veggies, cilantro and jalapeño.

REVIVAL ZEPPELIN CHICKEN WINGS

As much as we're obsessed with buffalo wings, we wanted to make our wing recipe a little different. Revival's Zeppelin, a traditional unfiltered German hefeweizen, is the ideal companion to this citrusy garlic-herb sauce.

2 pounds chicken wings

MARINADE:
12 ounces Revival Zeppelin
1 small yellow onion, diced
4 garlic cloves, pressed
1 lemon, juiced
¼ cup brown sugar
salt and pepper to taste

SAUCE:
¼ cup olive oil
1 tablespoon Revival Zeppelin
1 lemon, juiced
4 garlic cloves, pressed
¼ cup fresh herbs, diced (oregano and thyme work well here)
salt and pepper to taste

Combine all of the marinade ingredients and let the wings marinate, covered in the fridge, for a minimum of 1 hour but up to 24 hours. Preheat oven to 400 degrees. Line a baking sheet with parchment paper and place wings on sheet, with an inch between each wing. Bake for 20 minutes and then turn each wing over and bake for an additional 15 minutes. Toss wings with sauce (combine all ingredients).

APPENDIX I

NEWPORT STORM RHODE ISLAND BLUEBERRY BEER COBBLER

Newport Storm's Rhode Island Blueberry is a great beer for this cobbler—the subtle sweetness gives nuanced blueberry notes to the dough and the whipped topping.

FRUIT:

4 cups assorted berries (frozen works—blueberries, strawberries, blackberries)

¼ cup brown sugar

¼ cup white sugar

1 tablespoon cornstarch

½ cup Newport Storm Blueberry

DOUGH:

1⅔ cups all-purpose flour

2 teaspoons baking powder

¼ teaspoon salt

3½ tablespoons brown sugar

6 tablespoons cold unsalted butter, cut into ½-inch cubes

¼ cup milk

½ cup Newport Storm Blueberry

TOPPING:

1 cup heavy cream

1 tablespoon sugar

1 tablespoon Newport Storm Blueberry

Preheat oven to 425 degrees. For the fruit, combine the berries, brown sugar, white sugar, cornstarch and beer in a saucepan. Cook over medium heat until the mixture begins to thicken, about 10 to 15 minutes. Pour into a baking dish.

For the dough, combine the flour, baking powder, salt and brown sugar in a mixer. Add the butter and pulse until the flour resembles a coarse meal. Mix in the milk and beer. Using a spoon, add the flour mixture in small pieces to the top of the fruit. Bake 15 to 18 minutes, or until the top has turned light brown and the fruit is bubbling.

For the topping, whisk all ingredients in a stand mixer on high until peaks form, about 1 to 2 minutes.

RAVENOUS COFFEE MILK STOUT TIRAMISU

Coffee Stout and tiramisu belong together. You'll see why.

5 eggs, separated into whites and yolks
½ cup sugar
1 pound mascarpone
pinch of salt
1 tablespoon rum (try Thomas Tew barrel-aged rum from Newport)
24 ladyfinger cookies
3 cups Ravenous Coffee Milk Stout
2 tablespoons unsweetened cocoa powder
¼ cup bittersweet chocolate shavings

With an electric mixer, beat the egg yolks and ¼ cup sugar until light and creamy. Add the mascarpone and mix well.

In a separate bowl, beat the egg whites, remaining ¼ cup sugar and a pinch of salt until fluffy and somewhat firm. Fold the egg whites into the mascarpone mixture, along with the rum.

Dip each ladyfinger cookie in the stout (let soak for three seconds before removing) and lay each cookie flat into a 7x11 dish. Once the first layer of cookies is laid out, add a layer of mascarpone and dust with 1 tablespoon of cocoa powder. Place another layer of stout-soaked cookies on top and then another layer of cream and cocoa powder; top with the chocolate shavings. Cover the dish with aluminum foil (plastic wrap can sometimes stick to the cream) and refrigerate for at least 2 to 3 hours.

APPENDIX II

Beer Shopping

Planning a trip to Rhode Island? Here's a list of our favorite liquor stores and bottle shops, so that no matter where you are, you can stock up on some local brews.

Bottle Shops

B&C Liquors
253 Putnam Pike, Smithfield

Bottles Fine Wine
141 Pitman Street, Providence

Brickyard Wine & Spirits
1 Waseca Avenue, Barrington

Bridge Liquors
23 JT Connell Highway, Newport

Campus Fine Wines
127 Brook Street, Providence

Charlestown Wine & Spirits
4625 Old Post Road, Charlestown

City Liquors
1285 North Main Street, Providence

Grapes & Grains
24 Bosworth Street, Barrington

Haxton's Liquors
1123 Bald Hill Road, Warwick

High Spirits
559 North Main Street, Providence

I.M. Gan Discount Liquors
380 Warwick Avenue, Warwick

Kingstown Liquor Mart
6800 Post Road, North Kingstown

Madeira Liquors
174 Ives Street, Providence

Nikki's Liquors
32 Branch Avenue, Providence

Pier Liquors
29 Pier Market Place, Narragansett

Sandy's Liquors
717 Aquidneck Avenue, Middletown

The Savory Grape
1000 Division Road, East Greenwich

Town Wine & Spirits
179 Newport Avenue, Rumford

Vicker's Liquors
274 Bellevue Avenue, Newport

Wakefield Liquors
667 Kingstown Road, Wakefield

Wickford Package Store
41 West Main Street, North Kingstown

Wines & More
125 Sockanossett Cross Road, Cranston

Homebrew Supply Shops

Blackstone Valley Brewing Supply
403 Park Avenue, Woonsocket

Brew Horizons at Chepachet Hardware
916 Putnam Pike, Chepachet

Brew Horizons at Western Hardware
601 Washington Street, Coventry

Craft Brew Supplies
1133 Main Street, Wyoming

Silver Lake Beer & Wine Making Supply
65 Moorefield Street, Providence

Appendix III

Beer Terms

adjunct: fermentable material used as a substitute for traditional grains, used to make a lighter-bodied beer or to bring down costs.

alcohol by volume (ABV): the amount of alcohol in beer in terms of percentage volume of alcohol per volume of beer.

alcohol by weight (ABW): the amount of alcohol measured in terms of the percentage weight of alcohol per volume of beer.

ale: beer made with a top-fermenting strain of yeast and fermented at higher temperatures, the result often being a characterized fruitiness and esters.

amber ale (American): similar to an American pale ale but with more body and caramel notes, leaning more toward malt than hops.

anaerobic: an organism that is able to metabolize without oxygen present, such as lager yeast.

aroma hops: hops generally used as a finishing or conditioning hop to impart aroma.

astringent: a beer off-flavor often described as tart, vinegary or puckering; can be caused by tannins from steeping grains too long.

barley: a cereal grain that is malted to be used in the brewing mash.

barley wine: an oftentimes well-hopped interpretation of a rich and strong English ale.

barrel: a unit of measurement used by brewers; in the United States, one barrel equals 31.5 gallons.

Belgian dubbel: a rich, complex and malty Belgian ale with some spicy/phenolic characteristics; originated at monasteries in the Middle Ages.

Belgian tripel: bright yellow/gold in color, with a noted sweetness, complex yeast quality and a lighter body; usually has a well-hidden high-alcohol content.

Berliner weisse: a pale and sour yet refreshing low-alcohol wheat ale.

blonde ale: an easy-drinking, light malt-oriented American beer.

bock: a bottom-fermenting lager, generally stronger than your typical lager and with more of a robust malt character; types include doppelbock and eisbock.

body: the thickness property of beer, described as "thin" or "full" bodied.

bomber: a twenty-two-ounce bottle of beer.

brewhouse: the room or building housing the brewing equipment and where the beer is made.

brew kettle: the vessel in which wort is boiled with hops.

brewpub: a restaurant that brews and sells its own beer on premise.

bright tank (conditioning tank): the vessel in which beer goes after primary fermentation to mature, clarify and naturally carbonate.

brown ale (American): a malt-oriented and strongly flavored beer, often with caramel, toasty and/or chocolate flavors, with a medium to medium-high bitterness.

cask-conditioning: secondary fermentation and maturation in a cask, a barrel-shaped container usually made of wood.

cider: a beverage fermented from apples.

clarity: the transparency of beer—can be cloudy or clear.

conditioning: the aging period that allows beer to carbonate.

contract brewing: often referred to when a brewery hires another brewery to produce its beer.

diacetyl: a compound in beer that can contribute to a butterscotch off-flavor.

draft (draught): beer dispensed from a keg, tap or cask.

dry-hop: a method by which hops are added during the fermentation/conditioning phase to enhance aroma and hop flavor.

ester: a flavor compound created in fermentation; often fruity or flowery.

fermentation: the conversion of sugars into alcohol and carbon dioxide through yeast.

gose: an unfiltered German wheat beer with low hop bitterness and a dryness from the use of coriander seeds and salt.

growler: a reusable container, usually glass, used to buy beer on-site and bring home.

gueuze: a complex and pleasantly sour/acidic wheat-based ale, fermented by naturally occurring yeasts and bacteria.

head: the foam on top of the beer.

hefeweizen: a south German style of wheat beer with unique banana and clove notes.

hops: small green cones from the hop plant used to impart bitterness, aroma and flavor.

IBU (International Bitterness Units): a system of indicating hop bitterness.

imperial stout: also known as a Russian imperial stout, this is a strong, dark beer with a high ABV, usually around 9 percent or more.

India pale ale (IPA): originally brewed in England to survive the trip to India; today's American IPAs are descendants of the pale ale but decidedly more hoppy and bitter; imperial IPAs (7.5 to 10 percent ABV) are also increasingly popular.

keg: a half-barrel, or 15.5 U.S. gallons; a half-keg is 7.75 U.S. gallons.

kölsch: a clean, crisp and balanced beer, sometimes mistaken for a light lager or blonde ale.

lacing: the foam patterns left on the inside walls of a beer glass after the head dissipates; glassware that hasn't been properly cleaned can affect the amount and duration of head and lace.

lager: beer made with a bottom-fermenting strain of yeast and fermented at cooler temperatures, the result being a crisper beer without any esters.

lagering: from the German word for "storage"; the process of cold-temperature maturation to settle residual yeast, making for clean flavors.

lambic: spontaneously fermented sour ale from the area around the Senne Valley, stemming from a farmhouse brewing tradition; versions with added fruit such as *kriek* (cherries) and *framboise* (raspberries) are increasingly common in an attempt to reach a wider audience.

malt: barley, also known as grain; one of the four essential ingredients of beer.

mash: to release sugars by soaking grains in water; can also refer to the resultant mixture.

microbrewery: a brewery that produces fewer than fifteen thousand barrels of beer per year.

mouthfeel: the sensation coming from the viscosity of a beer.

nanobrewery: a small commercial brewery that uses a three-barrel or less brewing system, although this definition isn't set in stone.

Oktoberfest: a classic German malty lager, typically brewed in the spring, signaling the end of the brewing season, and served in fall during traditional celebrations.

pale ale: a beer with a generally good balance of malt and hops; American versions tend to be cleaner and hoppier, while British versions tend to be more malty and aromatic.

phenolic: an off-flavor and aroma of medicine, plastic, often referred to as a Band-Aid quality; can be caused by wild yeast or bacteria.

pilsner: a type of pale lager, usually crisp and clean with no fruity esters; types include Bohemian pilsner and German pilsner.

porter: a dark ale with English origins; in today's United States, porters are typically brewed using a pale malt base with the addition of black malt, crystal, chocolate or smoked malt.

Prohibition: the banning of production, importing, sale and transportation of alcohol via the Eighteenth Amendment, which was repealed thirteen years later by the Twenty-first Amendment.

rauchbier: an Oktoberfest-style beer with a sweet and smoky aroma and flavor, from the use of smoked malts.

Reinheitsgebot: a German purity law stating that the only ingredients used in beer must be malted grains, hops, yeast and water.

saison: a medium to strong fruity/spicy ale, highly carbonated, well-hopped and dry with a refreshing acidity; originating in Wallonia, the French-

speaking part of Belgium, saisons were intended to be thirst-quenching for the summer months.

stout: a dark ale with origins in England and Ireland; American stouts vary from high to low alcohol, and some are highly hopped, others are aged in bourbon barrels and others have added coffee or chocolate; examples of the style include dry stouts, oatmeal stouts and milk stouts.

Trappist beer: brewed exclusively by Trappist monasteries, of which there are currently ten—six in Belgium, two in the Netherlands, one in Austria and one in the United States.

wet-hop: beer brewed using hops fresh off the vine that haven't been dried or processed.

witbier: a wheat-based ale, often with an orange-citrus fruitiness and subtle herbal/spicy flavors such as coriander.

wort: the liquid extracted from the mashing process during the brewing process; contains the sugars that will be fermented by yeast to produce alcohol.

yeast: a microorganism in the fungus family.

BIBLIOGRAPHY

American Brewers' Review: A Monthly Journal Devoted to the Science and Practice of Brewing 31 (1917). http://books.google.com/books.

Baron, Charlie, and Chris Meringolo. E-mail interview by Kristie Martin, October 5, 2014.

BeerAdvocate. "Beer & Brewing Terminology." http://www.beeradvocate. com/beer/101/terms.

Beer Judge Certification Program. "BJCP 2008 Style Guidelines." http:// www.bjcp.org/2008styles/catdex.php.

Brinton, Jen. Phone interview by Ashleigh Bennett, August 11, 2014.

Broomfield, Nate. Interview by Kristie Martin. Pawtucket, Rhode Island, September 18, 2014.

Christy, Billy. Interview by Kristie Martin. Middletown, Rhode Island, July 16, 2014.

Clark, Lauren. *Crafty Bastards: Beer in New England from the Mayflower to Modern Day*. Wellesley, MA: Union Park Press, 2014.

Crane, Meredith. E-mail interview by Kristie Martin, September 8, 2014.

Crouch, Andy. *The Good Beer Guide to New England*. Lebanon, NH: University Press of New England, 2006.

DaRosa, Robert. Interview by Kristie Martin. Providence, Rhode Island, August 1, 2014.

Dunlap, Josh, Wesley Staschke and Andy Tran. Interview by Ashleigh Bennett and Kristie Martin. Wakefield, Rhode Island, September 14, 2014.

18th Century Material Culture Research Center. "Rhode Island Brewing History." http://www.scribd.com/doc/196011962/Rhode-Island-Brewery-History.

Garrison, Nick. Interview by Ashleigh Bennett and Kristie Martin. Pawtucket, Rhode Island, August 15, 2014.

Hamm, Richard. *Shaping the Eighteenth Amendment: Temperance Reform, Legal Culture, and the Polity, 1880–1920.* Chapel Hill: University of North Carolina Press, 1995.

Hellendrung, Mark. Interview by Ashleigh Bennett and Kristie Martin. Providence, Rhode Island, March, 24, 2014.

Krech, Shepard. *Passionate Hobby: Rudolf Frederick Haffenreffer and the King Philip Museum.* Bristol, RI: Haffenreffer Museum of Anthropology, Brown University, 1994.

Larkin, Sean. Phone interview by Ashleigh Bennett, August 8, 2014.

Lennon, Sheila. "Slated for Recycling—When, Where, What Happened to It?" *Providence Journal,* 2013. http://www.providencejournal.com/features/lifestyle/time-lapse/20130104-slated-for-recycling----when-where-what-happened-to-it.ece.

McConnell, Ray. Phone interview by Kristie Martin, June 2014.

McKay, Scott, and Jody McPhillips. "The Rhode Island Century: 1920–1930 in the Roaring Twenties the Question Here Was: What Prohibition?" *Providence Journal,* 1999.

McLoughlin, William G. *Rhode Island: A History.* New York: W.W. Norton & Company, 1986.

Miller, Norman. *Beer Lover's New England.* Guilford, CT: Morris Book Publishing, 2012.

Minutes from the Rhode Island Historical Preservation & Heritage Commission, January 8, 2014. Available at http://www.preservation.ri.gov/pdfs_zips_downloads/about_pdfs/public_info_pdfs/140108minutes.pdf.

Nangle, Bill. Phone interview by Kristie Martin, September 15, 2014.

Narragansett Brewing Company. "Narragansett Beer: Our Story." http://www.narragansettbeer.com/our-story.

Nashua Telegraph. August 27, 1937. Google Newspapers.

Oakley, Brian. Phone interview by Kristie Martin, October 14, 2014.

Olmstead, Robert. "Lucubrations Lovecraftian." http://www.scribd.com/doc/190144715/Lucubrations-Lovecraftian.

Pelletier, Nichole, and Jason Lourenco. Interview by Kristie Martin. Pawtucket, Rhode Island, September 2, 2014.

Prohibition. Directed by Ken Burns and Lynn Novick. PBS, 2011. DVD.

Rave, Dorian. Interview by Ashleigh Bennett. Woonsocket, Rhode Island, October 18, 2014.

Richardson, Matt. Phone interview by Kristie Martin, September 3, 2014.

Righter, Marshall. Interview by Kristie Martin and Ashleigh Bennett. Middletown, Rhode Island, August 7, 2014.

Ryan, Brent. Interview by Kristie Martin. Newport, Rhode Island, August 7, 2014.

Smith, Gregg. *Beer in Early America: The Early Years, 1587–1840*. Boulder, CO: Siris Books, 1998.

Tainsh, Tommy. E-mail interview by Ashleigh Bennett, August 20, 2014.

Theberge, Greg. Interview by Kristie Martin, April 7, 2014.

Warwick Digital History Project. http://www.warwickhistory.com.

Witham, Dave. Interview by Kristie Martin. Kingstown, Rhode Island, August 23, 2014.

Woman's Christian Temperance Union of Rhode Island. Organizational records, 1875–1971. Available through the Rhode Island Historical Society, http://www.rihs.org/mssinv/MSS811.htm.

Also included are archived materials from *Yankee Brew News*, *Providence Phoenix*, *Providence Journal* and *Rhode Island Monthly*.

Index

ABOUT THE AUTHORS

ASHLEIGH BENNETT graduated with honors from the University of Massachusetts–Amherst with a BA in journalism and a minor in cultural anthropology. After college, she worked as a freelance writer and photographer for various travel and lifestyle magazines and taught ESL in Italy. She came back to the States to work as a news reporter, and she now works in marketing research. She specializes in writing about craft beer and Cape Cod history, with a penchant for vanished seaside villages and maritime myths. Currently she lives on Cape Cod with her husband and cats. Her hobbies include reading, exploring the outdoors, feasting on fine foods, traveling, Halloween and fitness.

Kristie Martin has a BA in English and film studies from the University of Massachusetts–Amherst. She has spent the last five years working in the food and beverage industry across New England—craft beer sales, cooking, restaurant management and bartending. Currently, she works in Barrington, where she lives with her boyfriend and cat. She is a Certified Beer Server, studying for her Cicerone and BJCP licenses. When she's not at work or studying beer, she's usually in the kitchen with way too many burners going on the stove. She's also very happy when a day includes one or all of the following: a road trip, cheese, herbal remedies or a schlocky movie.

Started in 2011, twogirlsonebeer.com is a blog all about the New England beer scene—from beer reviews and in-depth looks at new breweries to bar guides and food pairings. The blog strives to bring a unique perspective to the beer blogging community through personal anecdotes and dual viewpoints.